MW00562395

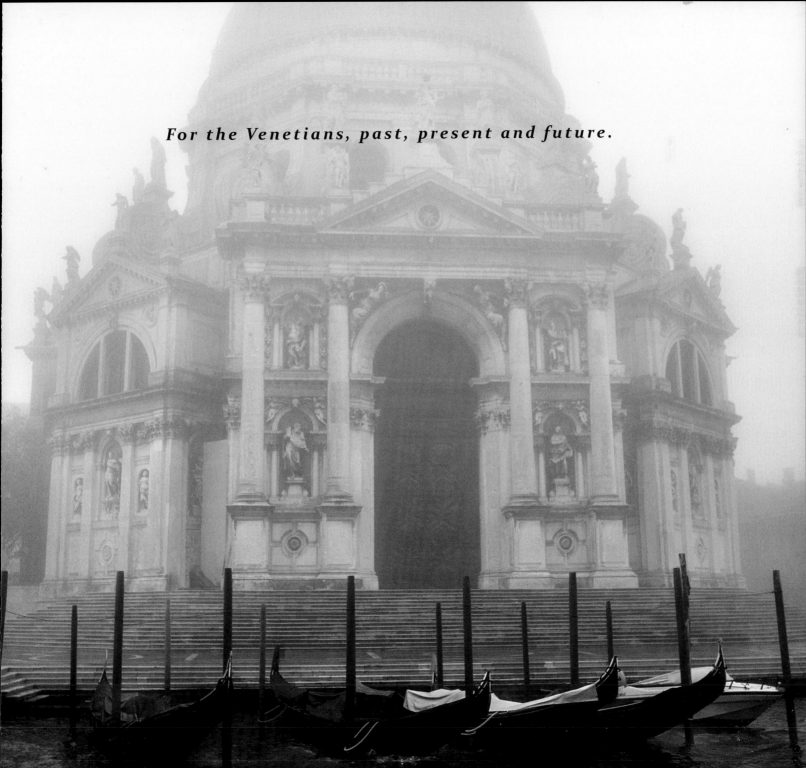

For the Venetians, past, present and future.

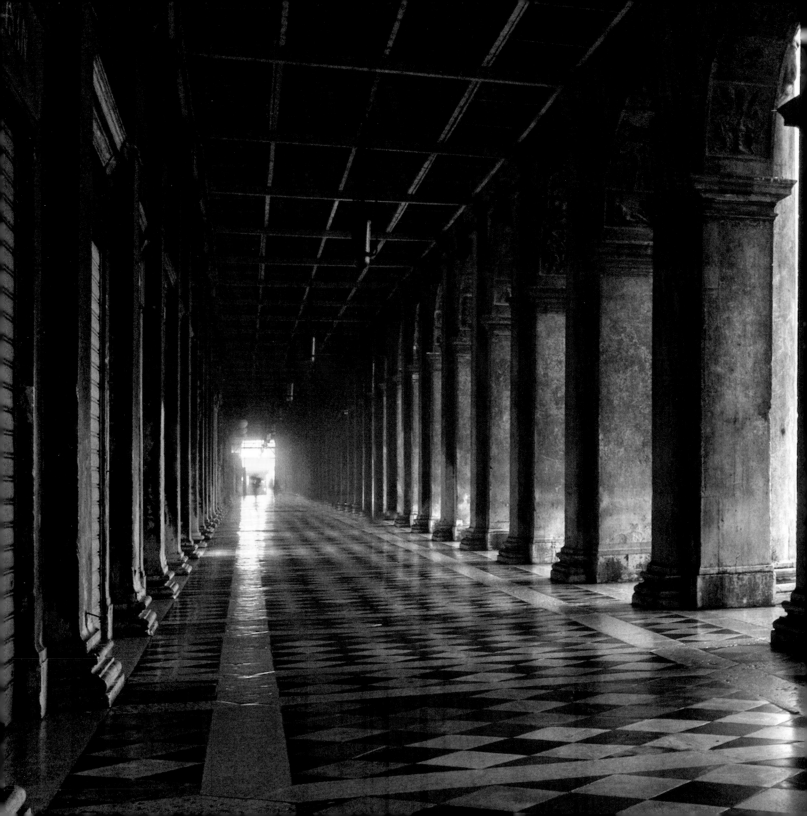

DREAM OF
VENICE
ARCHITECTURE

photography by RICCARDO DE CAL

introduction by RICHARD J. GOY

BELLA FIGURA PUBLICATIONS

PREFACE

What can we learn from a city that is over 1,500 years old? How does her immutable reality challenge our own sense of urban living? Venice was built where no land ever existed. Water runs through her veins. Bridges, palaces, churches, every structure is a testament to the resiliency of imagination.

For this book (the second in our *Dream of Venice* series), we invited contemporary architects and architectural writers to share their personal experiences of Venice. They reveal how the city has inspired their work and their lives. They write of humble things, of doors and decay. They encourage us to feel the city. They extol her complexity and her humanity.

Riccardo De Cal took a photograph for each essay. He has illustrated the words with an evocative Venice; one that basks in blue winter light, sleeps quietly and becomes an apparition when shrouded in fog. This is the Venice that greets you when you turn a corner and enter an empty *campo*. This is the Venice that is a contemplative paradox of stone and air. If we can understand what Venice offers us, we will respect her fragility. We will continue to learn her lessons, and cherish her existence.

We sometimes forget that with her majestic edifices and resplendent history, Venice is a city comprised of residents. It is to the Venetians we dedicate this book. Without them, there is no Venice.

JoAnn Locktov
Editor

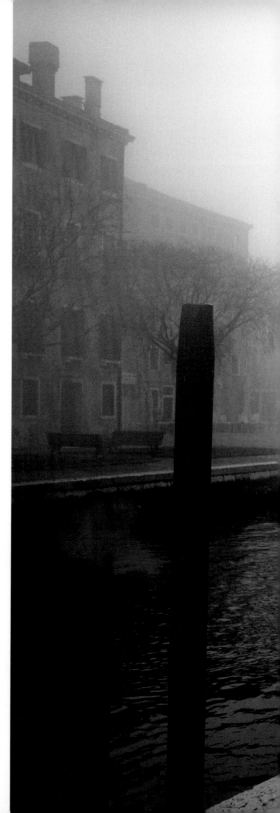

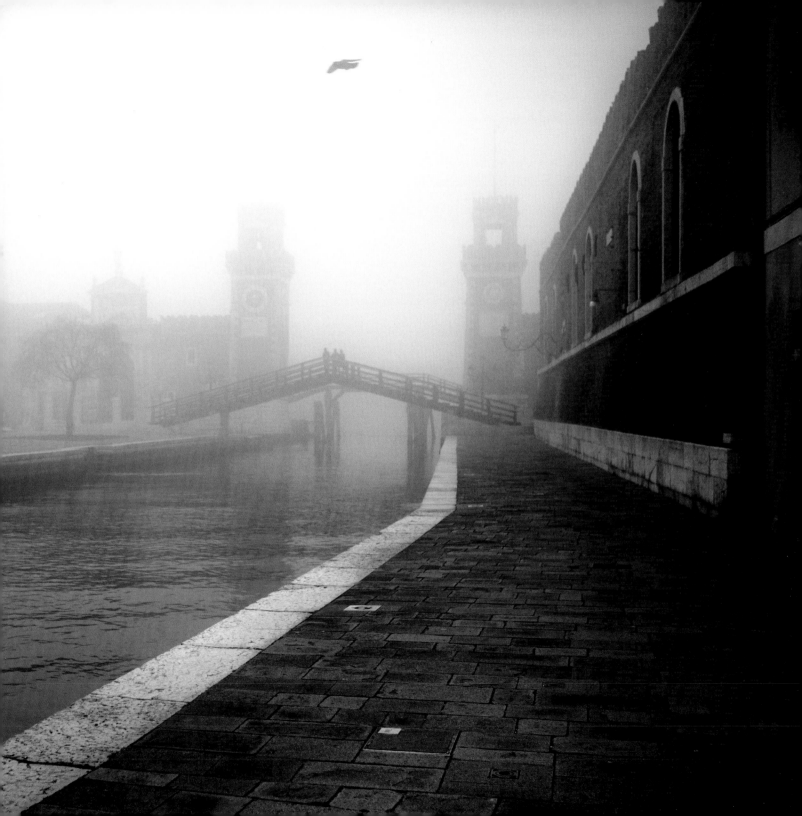

Fondazione Querini Stampalia
Onlus

Palazzo Querini Stampalia, a short walk from Piazza San Marco, is considered one of the most interesting architectural complexes in Venice. Its history is tied to the Querini Stampalia family and its last descendent, Count Giovanni. In 1868, he bequeathed all of his family's possessions to the city of Venice with the understanding that its real estate, furniture, art collections, and libraries would be accessible for public use. When Giovanni died, in 1869, the Palazzo became the home of the Foundation.

The Library—open until midnight and on holidays—contains manuscripts, incunabula (books printed in the 1500s), atlases and maps, as well as modern publications. With its furnishings from the 1700s and 1800s, paintings from the 14th to the 20th centuries, porcelains and biscuit pottery, sculpture, globes, mirrors and chandeliers, the Museum transmits the atmosphere of a patrician dwelling and offers a voyage through the history of art, from the Renaissance of Giovanni Bellini to the 18th century works of Giambattista Tiepolo, Pietro Longhi and Gabriel Bella. Important lines of investigation and careful reflection for gathering the most advanced up-to-date proposals are present in the areas of architecture and contemporary art, including the sectors of literature, poetry, music, dance, graphics, and design.

Significant architectural restoration of the Palazzo has been carried out by Carlo Scarpa, Valeriano Pastor and Mario Botta: three diverse interventions which have both enriched the historic areas of the 16th century mansion and created new spaces for cultural initiative and special events.

The Foundation Querini Stampalia is sustained by its patrimony and public financing but it is especially thanks to the generosity of private individuals, that it is kept alive and active. For more information, including how you can join in the Foundation's mission, please visit querinistampalia.org.

A portion of the proceeds from each book will be donated to Foundation Querini Stampalia to support their architecture programming in Venice.

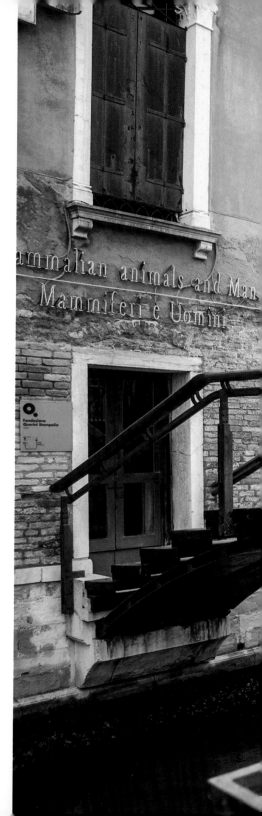

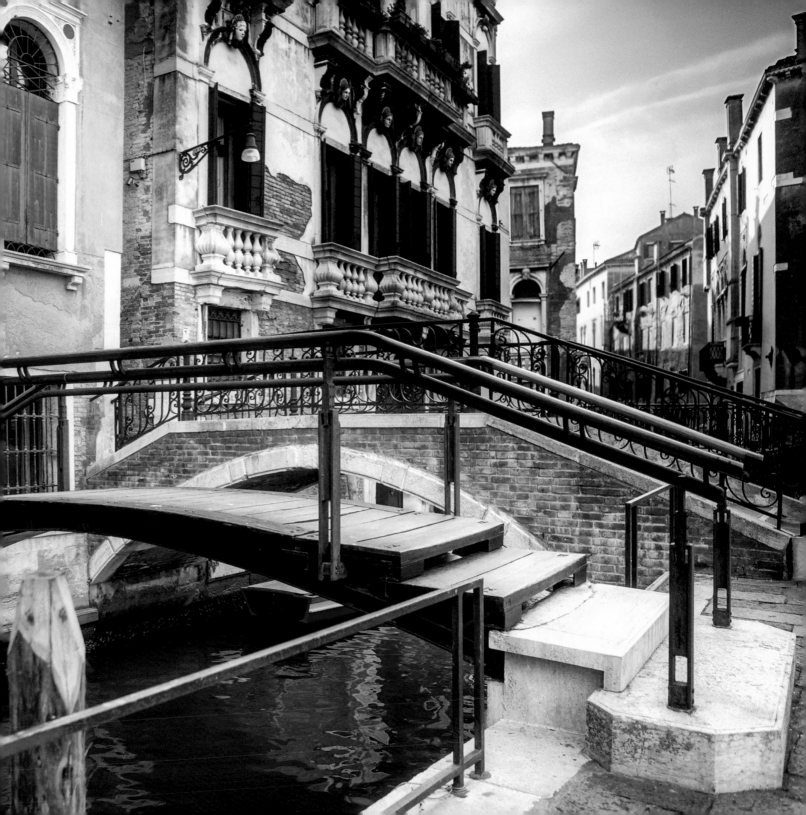

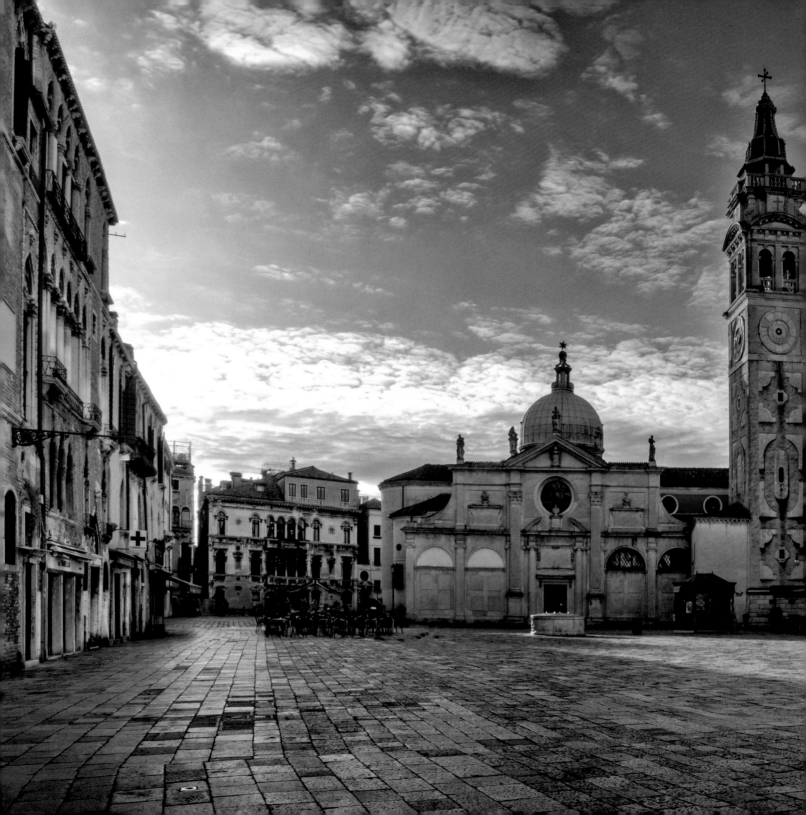

INTRODUCTION

Richard J. Goy

Venessia.
That is what Venetians call their home city; not Venezia but Venessia. This is not Italian; it's the Venetian dialect, their own language. Pronounced with a soft double "s," and delivered in those delightfully rhythmic, undulating cadences reminding me of the ebb and flow of the tides.

Language, the Venetian language, remains vitally important in this unique city. We can see it on a thousand *nizio'leti* (street-signs); it is still spoken every day by dozens of gondoliers and thousands of residents. It is all of a piece with the city's millennial history and its physical fabric. For centuries, official documents of the Most Serene Republic were written in *venessian*, not in Italian.

The red and gold *gonfalone* of the winged lion, Mark, the Evangelist and the Republic's protector, is also everywhere. The standard is sold to tourists and still hangs from *palazzi* two centuries after this fabled Republic ceased to exist. Such is the continuing power and importance of history, tradition and identity.

That ebb and flow, both of the music of the language and of the tides themselves, are part of the city's identity, its *raison d'etre*. Although it is claimed, somewhat prosaically, that very few *venessiani* can even swim these days, the tidal ebb and flow are always there, at the end of every *ramo*, slapping and sloshing along the banks of every *fondamenta*. They are there when the tides are so low (*bassa marea*) that some of the canals become impassable. And they are there when the sirens start to wail, and when the venessiani and we lucky part-time residents reach for our *stivali* (boots), and peer gingerly out into the *calle* submerged under *acqua alta*. Water. The element from which the city emerged, Venus-like, in just one of the many conceits that the Republic fashioned, to glorify and mythologize its origins. Botticelli transposed to the Lagoon.

Two questions are asked more than any other about Venice—and I have been asked them countless times—why? and how?

Why was this glorious, absurd city built in this preposterous location, surrounded by labyrinthine creeks and malodorous marshes? And how was it built on such challenging, seemingly impossible terrain?

The answer to the first one is relatively easy: as history relates, it was a place of refuge in the 5th and 6th centuries, a haven at a time when nowhere else on the northeast Italian mainland was safe. And because these margin-dwellers already knew these lagoons, these creeks, these mud-banks; they knew, too, how to navigate their sometimes treacherous waterways; knew where to catch their abundant fish and seafood; knew which were the large, firm islets on which it was possible to build.

And so they began to build. Safe in the knowledge that the terra firma threats could not reach them on these low-lying reefs. Simple timber dwellings at first, with roofs of osier thatch, much like the little *casoni* that survive in the most remote northern lagoon. Slowly, they were replaced by heavier, more permanent structures, brick, this time, with roofs of timber and tile. This is how the nascent Dogado slowly developed from a turbulent collection of squabbling islet-towns—firstly into a confederation, and then into a Republic.

As to the how: well, again, very special physical environments require very specific responses, and the venessiani, through ingenuity and tenacity (and notably increasing wealth through trade), devised a range of construction techniques to enable them to build where no other Italian considered it possible. How?

Essentially, by driving millions of timber piles into the firm clay subsoil, then building rafts (*zattere*) of timber—oak or larch—on top. Above these rose the brick and stone walls of their churches and palaces, on these stout decks of rot-proof timber. They were almost always remarkably successful: the Palazzo Ducale still stands on timber piles driven into the clay 700 years ago, which are as good as new. On the rare occasions that they have failed, the reason was usually simple: exceptionally heavy point loads exerted by the city's hundred-odd *campanili* were sometimes simply too much for the foundations to support. They developed alarming inclinations (Santo Stefano, the Greci) and occasionally they succumbed, as, most spectacularly, at San Marco in 1902. These failures, though, were rare.

Naturally enough, down the centuries, both the city's proud noble residents and its notable visitors have

been awe-struck, not to say bewildered, by this nature-defying vision.

Petrarch, for example, arrived here in exile in 1364, and managed in a few lines to summarize not only the admirable qualities of the Republic itself ("...the one home today of liberty, peace and justice, the one refuge of honorable men..."), but also to acknowledge the remarkable physical achievements of its building, while heaping still more praise on the institutions of the La Serenissima: "...solidly built on marble, but standing more solid on a foundation of civic concord, ringed with salt waters, but more secure with the salt of good counsel..."

More than a century later, it was a proud Venetian noble, Marin Sanudo, who eulogized his magnificent capital city, then at its mid-millennial peak of splendor. In his description of Venice and its government in 1493, he praises the Venetians' skill in devising these unique construction methods, "with great ingenuity" and "'not in the way that they build them elsewhere." In his view, Venetian builders and pile-drivers were far superior. And Sanudo's words were echoed visually at almost exactly the same time by Jacopo de'Barbari's magnificent aerial view, the original woodblocks for which may still be seen in the Museo Civico Correr.

How to characterize and thus comprehend this most enigmatic and complex of cities? Countless writers have tried over the centuries, using a myriad of metaphors, similes and flights of rhetoric.

One practical way is to consider Venice as a tightly packed collection of tiny villages, each with its own campo, parish church and noble palazzi. This is indeed how the city coalesced over time, almost like a miniaturized version of the hundred-odd villages surrounding London before they all expanded and joined together to form a vast, contiguous urban whole. Here, though, every campo remains unique, every island parish retains its own identity. Most also retain their palazzi and parish churches.

Another way might be this. A few years ago, Roberto Alajmo wrote a wonderfully idiosyncratic introduction to his home city, Palermo, which is entitled *Palermo e' una Cipolla* (Palermo is an Onion). And Tiziano Scarpa has described Venice; perhaps more obviously, as a fish, using the human senses as extended sensual metaphors for the experience. But in many ways the onion analogy, although certainly less romantic, is more applicable to Venice than it is to the beguiling capital of Sicily. Alajmo means, of course, that a city reveals itself in layers, one at a time.

Venice's urban form can be considered as a series of roughly concentric layers, each one concealing the next one as we progress further and further inwards. Thus we need to reach, to discover, to explore, and then peel away each of the outer layers in turn to reach the next one. The 'rough' outermost layer, is represented by the furthermost reaches of the Giudecca, scruffy and post-industrial, or the peripheral glass-making island-town of Murano, struggling, but still working for a living. These are the city's periphery.

Towards the center, the greenery decreases, the density increases, the *campi* become more truly urban and well defined with the splendid squares of San Polo, Santo Stefano, Santa Maria Formosa. This is the fully characterized grain of the mature city: tight, dense, and refined.

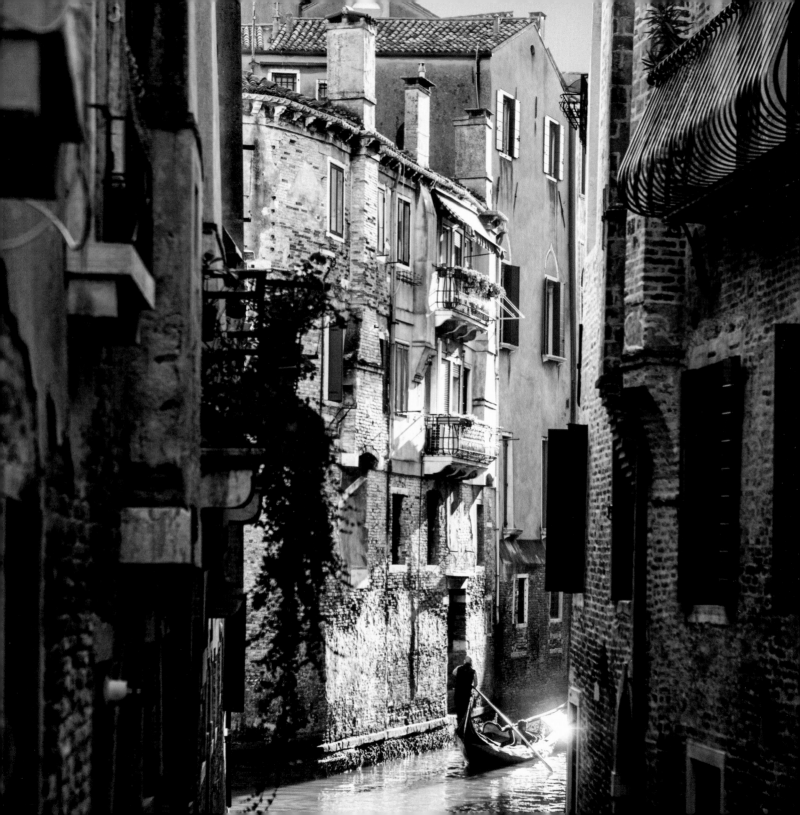

And finally, in the very center of this splendid *cipolla*, we come to the Piazza and Piazzetta, the Basilica, the Palazzo Ducale, and the other monumental structures that collectively define the heart of the millennial Republic. Even here, in the Piazza, in fact, there is still one more layer to penetrate. We must enter the ancient portals of San Marco and survey the mosaics; stand in the center of the hall of the Maggior Consiglio, the Senato and the Collegio; absorb the sense of wealth and power.

How else might one characterize this extraordinarily complex city-organism? Well, the simple truth is that we are all a little like Calvino's Marco Polo: "Every time I describe a city I am saying something about Venice." Henry James called it "a sort of repository of consolations." To Ruskin it was, "A wonderful piece of world. Rather, itself a world." Dickens described his entire visit as a dream sequence; Daphne du Maurier (and later Nicolas Roeg), by contrast, conjured up a wintry nightmare.

We all, millions of us, each have our own personal Venice, a kaleidoscope of colors, sounds, smells, memories, reflections—some images fleeting or perhaps just fragmented shards of images...an infinite mosaic as rich and complex as those in the Basilica. Every one is different.

My own dream is firmly rooted in the reality of the living city. Campo Santa Maria Formosa is only a two-minute walk from my own Venetian apartment. It represents, to me, an essential part of the real, living Venice: the city of its inhabitants, not the city of a million *turisti mordi e fuggi* (day trippers). Two aspects of this square render it, for me, a distillation of the city.

Firstly, it is surrounded by a splendid array of palazzi, spanning the centuries from Palazzo Vitturi (13th to 14th centuries), through the gothic palazzi Dona' to the early Renaissance Palazzo Malipiero and the early 17th century Palazzo Ruzzini Priuli. And projecting into the Campo to the west are the three elegantly curved apses of Mauro Codussi's wonderfully refined early Renaissance parish church, still very much in daily use.

This is the second aspect of the Campo that is so vital as a metaphor for the city's future: it is the life in the Campo itself that fills me with the hope that Venice can and will remain a real city for real Venetians. Within the square are many of life's daily necessities—a newsstand, a fruit and vegetable stall, a bar, a pharmacy, a cash machine, and one or two other stalls. On the Calle Lunga a few yards away we find an excellent butcher, a remarkably eccentric bookshop, and two or three flourishing *trattorie* and *bacari*. The essentials of daily life.

Every square meter of the Campo is used, for a wide range of functions and activities. Six-year-old boys kick footballs around at the top end; retail activities are concentrated in the central section, where all the pedestrian routes come together. At the south end, small toddlers scream around on their plastic tricycles. And in the far southeast corner, by the Ruga Giuffa bridge, is the gondoliers' stand. This is the living city that must survive and thrive.

Louise Noelle

Near midnight, the bells of the Basilica of San Marco toll in a particularly insistent way: they call the faithful to the Resurrection Mass. It is the end of Holy Week in a Venice overflowing with tourists and one feels in the air that spring has arrived—the bronze clanging in the silence of the full-moonlit night has a rhythm and pulse that draws me to the great Piazza and I enter the temple.

The history, which seems more like legend, conveys that around the beginning of the ninth century a group of seasoned Venetians absconded the remains of St. Mark the Evangelist, who had been the first Bishop of Alexandria where he had been laid to rest, a city that had become Islam. This circumstance led to the initial construction of a basilica, to celebrate St. Mark who, from that moment on, became the patron saint of the city. This was before various vicissitudes led to a reconstruction, undertaken in Byzantine style in 1064, as an extension of the Doge's Palace.

The richness of its interior, the result of many years during which wealthy Venetians provided ornaments and diverse works of art, is crowned by the famous mosaics; these are illuminated for the religious ceremony. The internal space thereupon takes on another dimension: that of reflection and devotion, which resonate with a profound sense of music from times bygone, which infuses the canticles that bear us toward the divine with piety and fervor. The atmosphere and voices restore true religiosity—beyond the simple curiosity of the tourist—recuperating memories that take us back into forgotten rituals. We become a part of the millennial building with its powerful dimensions, its sublime opulence, its luminous mystery, its celestial harmonies, and its rich spirituality.

Frank Harmon

The Fabric of Venice

We tend to remember cities for their monuments. The Eiffel Tower, St. Paul's Cathedral, and the Chrysler Building are Paris, London, and New York icons. Venice also has its monuments: La Salute, the Campanile of St. Mark's and Ponte di Rialto. But the most important buildings of Venice, to my mind, are the ordinary houses, workshops, and trattorias flanking the canals. They are the fabric that holds Venice together. And what special buildings they are.

Venetian buildings are deeper than they are wide. Builders carved tall windows at the corners of rooms so daylight would wash the flanking walls and penetrate deeply into the interior. The façade of a Venetian house resembles a carpet stretched out to dry. Its windows form a geometric pattern on walls washed in Venetian red and burnt sienna. The bottom of the wall ends in a thin line against the water. The top is an equally thin line against the sky. Thus, in certain light the buildings seem suspended on a mirror of water under an azure sky, like shimmering planes of color.

Venetian buildings have no cornices or overhangs because sunlight is as likely to be reflected from the water as from the sky. This further enhances their appearance as planes of pure color. Paintings by Bellini, J.M. Turner, and J.S. Sargent depict this hovering quality. The Venetian esthetic probably developed as a practical way to build in this particular watery place. Its vernacular principles were used to build grander structures. The Doge's Palace façade, for example, could be thought of as a rose-and-white tapestry hemmed with lace. Venice gives us a sense of wonder. It catches us off guard and shakes up our small, habitual sense of form. After a visit to Venice, everything feels more spacious.

Carlo Ratti

"Every time I describe a city I am saying something about Venice," states Marco Polo in the book *Invisible Cities* by Italo Calvino. It seems strange that such a unique city could become the archetype of all the cities in the world. Yet its development has something universal: Venice is an extraordinary example of how man is able to adapt the environment to his own needs, improving livability and creating a harmonious relationship between nature and technology.

Apart from the enchanting sights—the restored façade of the Fondaco dei Turchi; the staircase of the sumptuous Scala Contarini del Bovolo; the hidden courtyards; the mysterious islands; the *altane*, so ancient to be nearly post-modern—here is what impresses about Venice. Architecture always had the task of creating an interface between us and our surroundings. In Venice, this task seems to have reached perfection where the water merges with the structures and becomes both road and border; where work, salt and mud become the foundations for ornate palaces.

In such a beautiful urban environment, there are two main challenges: on the one hand, the upkeep of this balance and on the other, the possibility of change. A city that has its own fortune in its crystallization cannot however reject to renew itself. Just like in the past, Venice must create a new equilibrium with its environment, which today is not solely a physical one but is made of both atoms and bits. We have to be able to add a digital level of intelligence to the city, an invisible layer, like the foundations of mud—or like Calvino's cities.

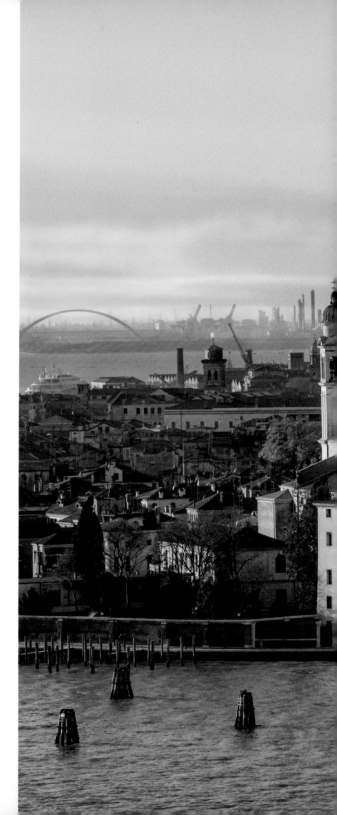

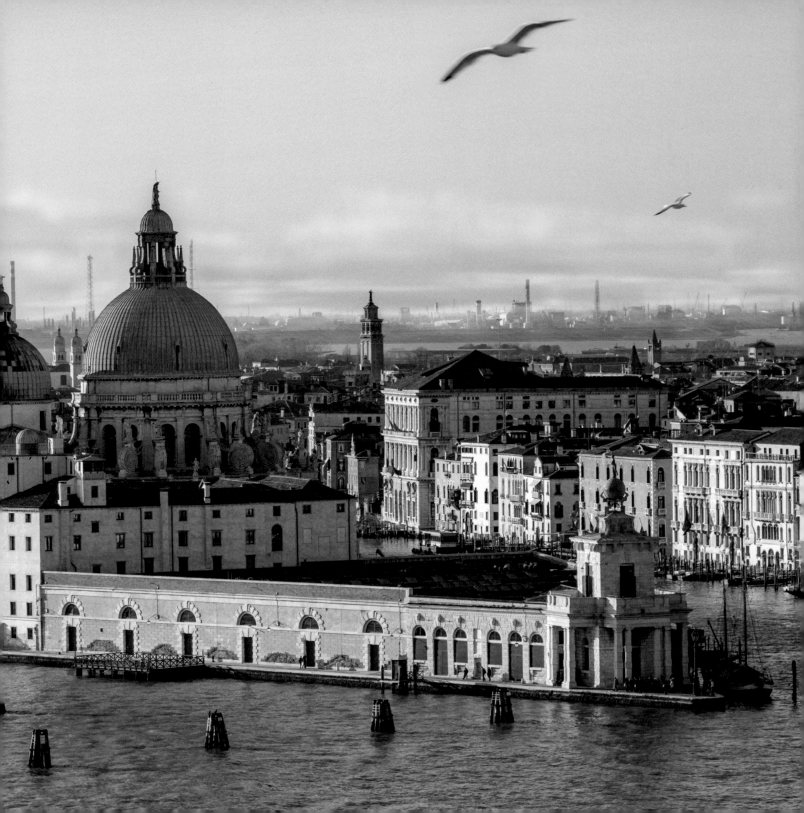

Diana Yakeley

Hortus Conclusis – The garden of the Fondazione Querini Stampalia

The design of small inner city gardens is always complex. The constraints of shade, aspect, privacy and the need for an oasis of calm often result in overly designed, over-planted and impractical spaces lacking the contemplative sense of place, which to me is the essence of a garden. Carlo Scarpa created this, perhaps the most perfect small city garden in Europe, and with the daunting design constraint, regular flooding from brackish water. With great sensitivity, Venetian-born Scarpa designed the narrow rectangular space to embrace and celebrate the essence of Venice—water, antiquity, Moorish influences, the play of light on Murano glass, in an elegant and seemingly simple way. Textures and contrasts provide the sensuous delight—a rough concrete wall is set with squares of fragile glass *tesserae*, a mosaic of glittering gold, silver and black tiles. These tiles also appear shimmering under water in a tank planted with water lilies, the only flowers apart from a single spare Japanese Cherry tree set in the lawn.

Water, the protagonist, is celebrated and lovingly manipulated through channels and complex stone mazes cut into Istrian stone and past magnificent fragments of classical sculpture. Bronze spouts pour the water to lower levels, creating bubbling sound installations that are amplified by the high walls surrounding this sublime space.

Birds—more often in cages in Venice—bathe gratefully in the watery pools and sing from the fruit tree's branches. Even the water-loving Papyrus in the narrow rill to one side of the garden pay subtle reference to the magnificent library within the Foundation.

This Hortus Conclusis is an exercise in form, function, materiality and a deep understanding of creating a sense of place. It is seemingly simple, yet upon close examination shows complexity in immaculate detailing. Visual references to the culture of Venice are brought together harmoniously in this oasis, without the clichés that could have been. For me it is perfection.

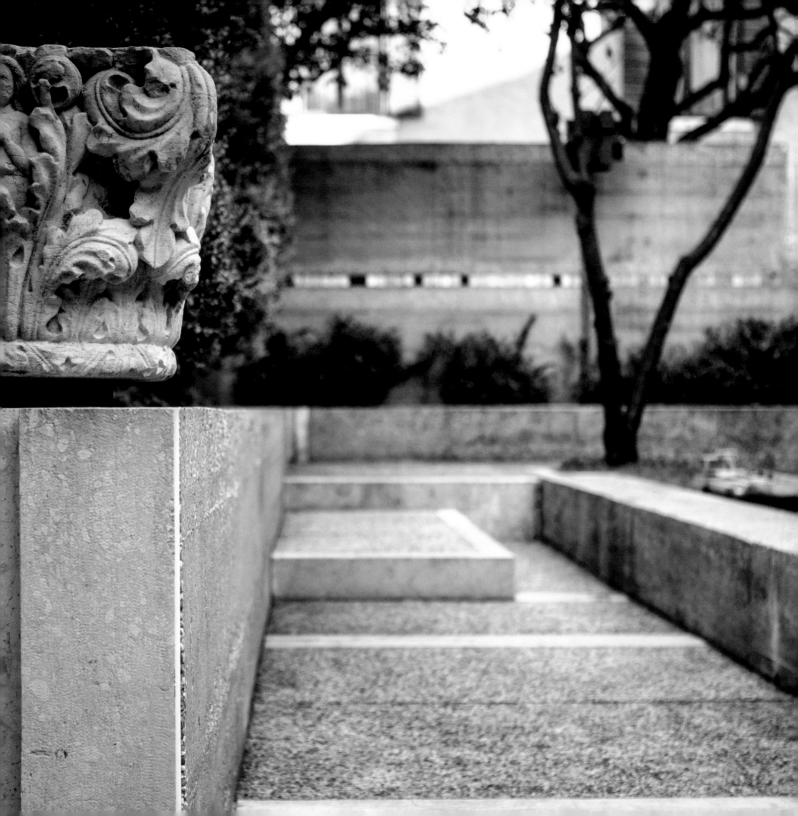

Guy Horton

Venice always strikes at me from afar, from D.H. Lawrence, Mann, and Voltaire. From Calvino's *Invisible Cities*, of course. I kept a battered, used copy (which doubled as a convenient and inexpensive notebook for my own scribblings) next to my equally battered and equally used laptop when I was an architecture graduate student back in the nineteenth century. And from the more obvious Architecture Biennale, where Rem seemed to say nothing about Venice but everything about everywhere else.

I am not ashamed to say I have never been there. I have been to many places and have not been to many places. Venice is one of the "have not been to" places...until I go. But I have no plans at the moment to go—unless someone foolishly sends me there to write something about it. Yet, somehow, I am always asked to write about this place I have never been to. I can never escape Venice.

I think, if I ever go, it would corrupt me and I would suddenly be unable to write about it. What is the saying? Visit for a week and write a book. Stay for a year and you can't write anything. What if I never go? I could write about Venice forever—even after the sea swallows it. The new habitable datum will be the second floor. All stairs will lead to water. This is now a line drawn horizontally across the city. I think it should be drawn for real, on buildings and monuments, before the water comes. I should write a grant proposal to do this. Maybe then I would have to go.

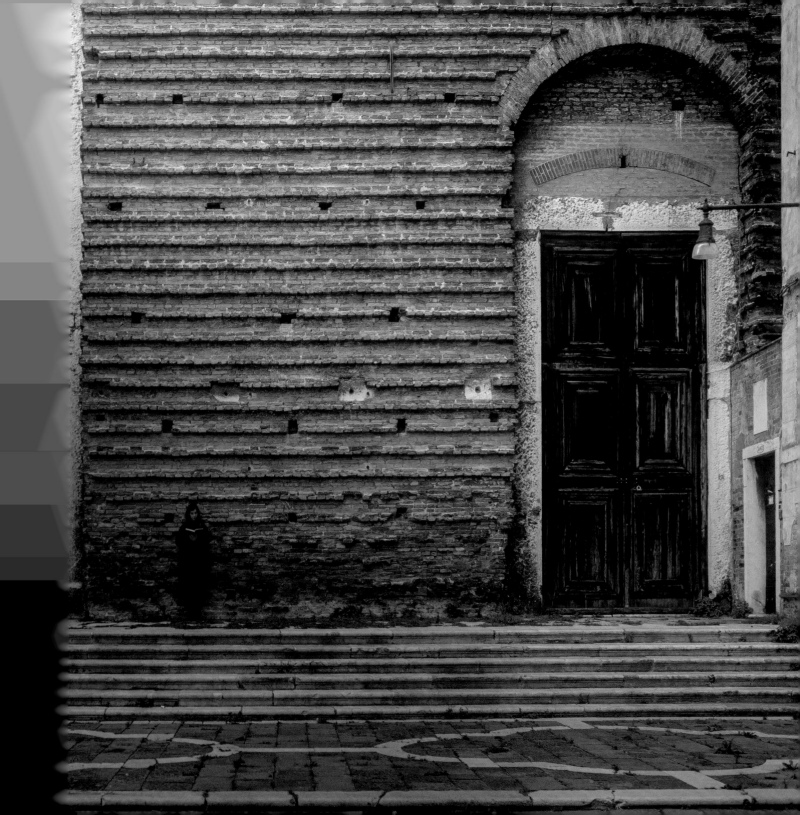

Tadao Ando

Recollections in Venice

In 1992, I designed an open-plan wooden pavilion for the Universal Exposition of Seville in Spain. This project brought me the opportunity to work in Venice. I was commissioned to design an art school for Benetton Group, asked by Mr. Luciano Benetton—who visited and appreciated the Expo'92 pavilion—to renovate a 17th-century villa in Treviso, a suburb of Venice.

An important aspect of working overseas is the enticement of each city when there are pieces of architecture and townscapes I personally wish to see. Venice, of course, appeases these anticipations. In this beautiful city, there are dense layers of history such as Piazza San Marco and works of Andrea Palladio and Carlo Scarpa. This fact had already inspired me to want to work in the city before any opportunities had come my way.

After these initial undertakings in Venice, I became involved in two important revitalization projects—the Palazzo Grassi and the Punta della Dogana, commissioned by Mr. Francois Pinault. These projects included restoration and conservation of historical buildings while simultaneously requiring the establishment of new spaces within the old structures. Though we struggled with many difficulties throughout the projects, we were supported by the Venetians' strong dedication to architecture. We organized a team with local engineers and historians, and united our objectives in order to tackle these comprehensive undertakings. More than anything, what deeply impressed me is the fact that they truly love architecture.

Though the Japanese culture has developed the habit of repeating "scrap and build" philosophies based upon economic rationality, I believe that architecture should be essentially rooted in society and be immersed in a lapse of time. This is exactly what I learned in Venice. Genuine affection for architecture and the city is spontaneously shared among the Venetian people. The projects in Venice brought me chances to contemplate what architecture should be, which became a precious experience for me.

Punta della Dogana
Ando

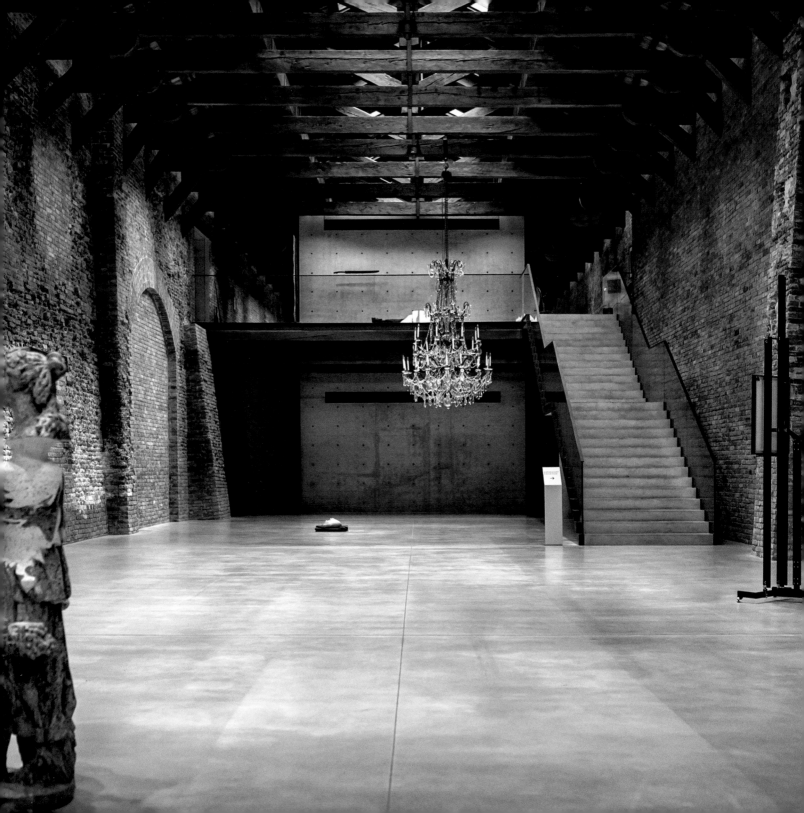

Annabelle Selldorf

I have a deep affinity, a kind of uncanny attraction, to the city of Venice. How is it that certain places draw us back time and time again, as if guided by subconscious attraction or even fate? I remember clearly the many times I have found myself in Venice, the visits during my childhood, returning as an adult and also to work there as an architect. Some of these visits coincided with episodes of loss and emotional turmoil, times when the melancholy that belongs to Venice is medicinal.

For so many people, cities are captured by the visual memory of an iconic panorama but for me Venice is a wholly visceral experience where what we see is so much less than what we perceive or feel. In Venice, there is all at once the sound and smell of the water, the *chiaroscuro* of confined passageways that give way to expansive *campi*, the constant rise and fall of crossing so many bridges and the twisting irregularities of its labyrinthine streets. A place of great intensity; I know no other city where one must navigate by way of intrinsic memory rather than conscious understanding.

Like the water, splendor envelopes the city but it is also subject to the perverse—where the domes of *Santa Maria della Salute* are dwarfed by the monstrosity of cruising megaships, the *Rialto* crumbles under the weight of tourists, and the most magnificent *palazzi* are forced to admit putrid lagoon waters inside. It is this coexistence of immense pleasure and profound sadness that makes Venice, for me, the perfect place. But Venice is also tricky. There is nothing innocent or forthright and deception is everywhere, perhaps used with the intention of protecting a precarious paradise. These contradictions fascinate me. By challenging my sense of order and hierarchy Venice gives me the desire to probe beyond the rational.

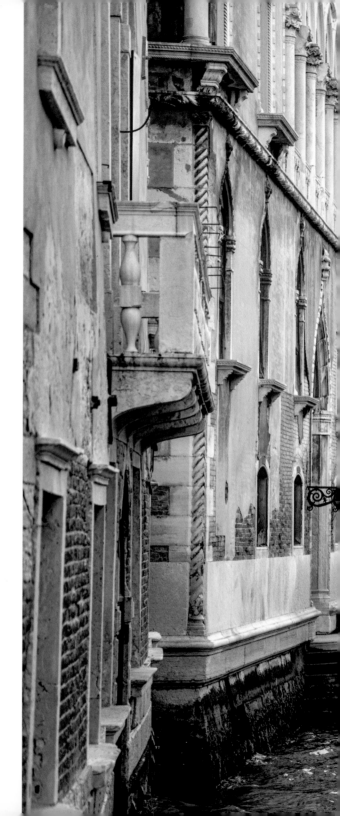

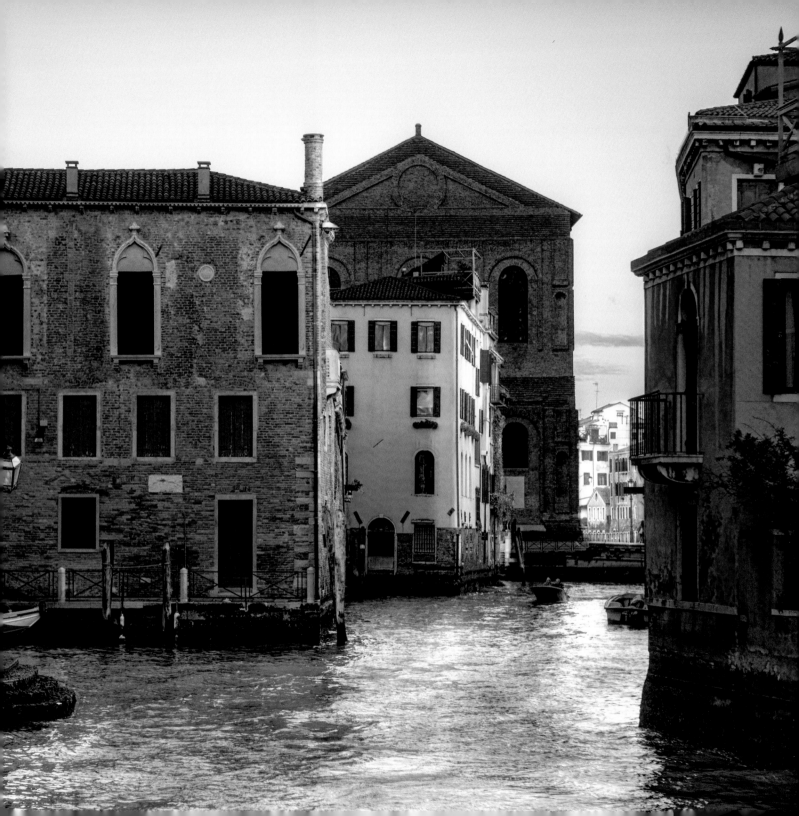

Robert McCarter

When I first visited Carlo Scarpa's renovation of the Fondazione Querini Stampalia, I realized that I was never far from the water of Venice, which, in reality and by implication, appeared beneath me and beside me at every point in my perambulations. This was most subtly evident when I stepped down onto the marble mosaic floor of the entry hall. The vibrant, shimmering floor is made of a complex, non-repeating pattern of small L-shaped, three-quarter square stone pieces, in white and pink-orange marble, with inset smaller square pieces fitting into the one-quarter square void of the L-shaped pieces, in dark green and dark red marble.

While the colors of the stones were reminiscent of the floors of ancient Venetian churches, such as Santa Maria dei Miracoli, the seemingly random and visually entrancing pattern was something entirely unfamiliar to me. A tall curb, faced in Istrian stone, edged the marble mosaic floor, and between the new curb and the existing walls was a moat-like trench that contained the *acqua alta* that allowed the room, whose floor was well below the flood line, to be used in all seasons.

Pipes that run through the exterior wall connected the perimeter trench to the canal, allowing water to enter and depart as the acqua alta rose and fell. Even when dry, the curb and trench serve as a reminder of the intimate relation of the city of Venice to the water in all seasons. When I visited during acqua alta, with the water filling the moat-like trench and surrounding me, the flickering reflections of sunlight bouncing off the surface of the water played across the walls and ceilings, and mingled with the shimmering surface of the mosaic floor—the entry hall allowing me to experience Scarpa's unique interpretation of his place, Venice.

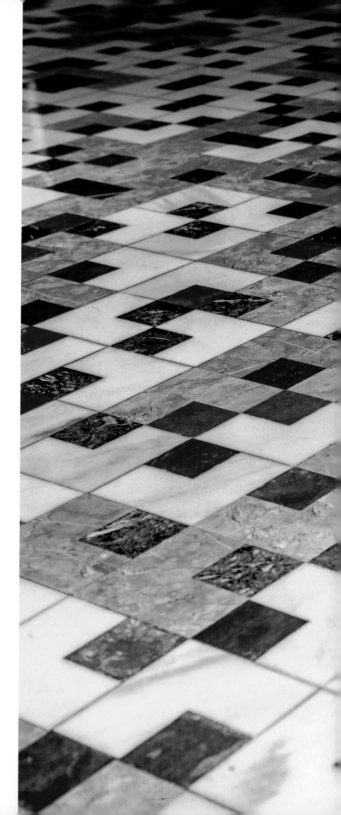

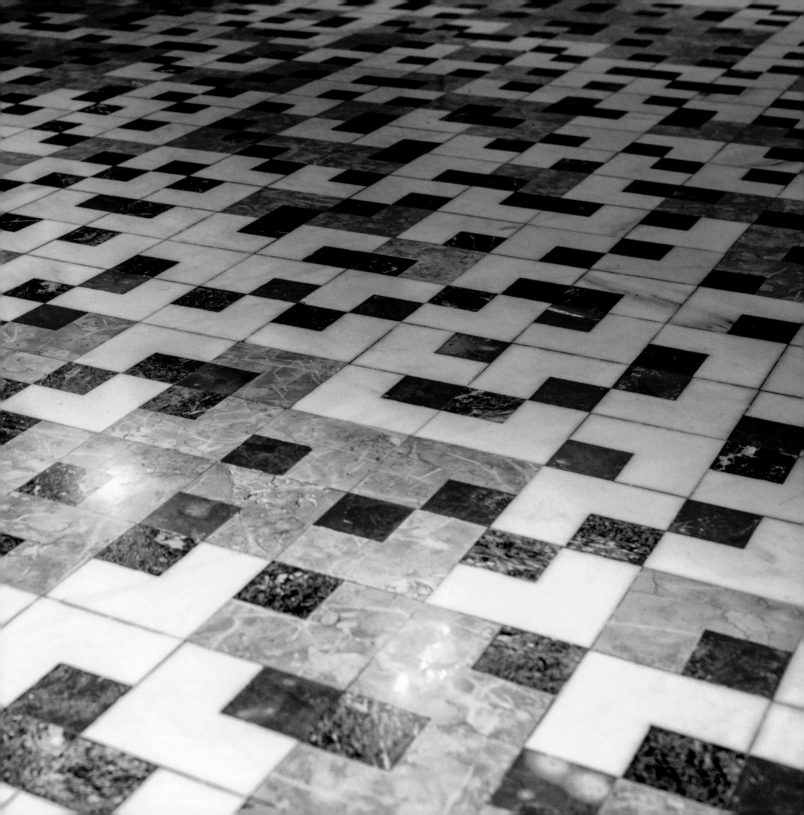

Constantin Boym

Doors of Venice are impossible to miss. Walk on any alley off the beaten track and every few steps you'll encounter these monumental aged entrances on both sides of the street. Typologically, they are all similar: a massive wooden double door set inside a stone or marble frame. Of course, like everything in an old city, each portal has its own unique face and expression.

I do not know if a taxonomy of Venetian doors has ever been made. To compile one would be a lengthy and immensely satisfying task. One could note, for example, the variations in wood paneling; the location and style of handles; the placement of bronze mail slots; or the tiny lookout windows, always protected by massive iron bars. Some doors feature almost illegible darkened bronze name plaques while others display well-worn metal kick plates, which seem to show old boot marks. Most importantly, such taxonomy should include the degree of aging—one could say, of deterioration—of the doors from dignified patina of age to almost complete decay of wood boards that seem to hold together only by a miracle.

Every entrance has a four-digit number, always applied onto the frame in a uniform stenciled typeface. A few years ago I happened to be passing by the house numbered 1937, which featured a particularly distressed and ominous-looking door. Suddenly I had a strange vision that the horrific memories of the year 1937—Guernica, Kristallnacht, Stalin's Great Purge—are hidden behind that locked portal. It took a good half-a-bottle of wine before I could let this disquieting fantasy go. Yet ever since, I cannot rid myself of an impression that every Venetian door represents a particular year; that the city is, in fact, a museum that contains all human history and all our future as well. This would, of course, explain why the doors are so mysterious and forlorn: why they are always locked; why nobody ever seems to be entering or coming out.

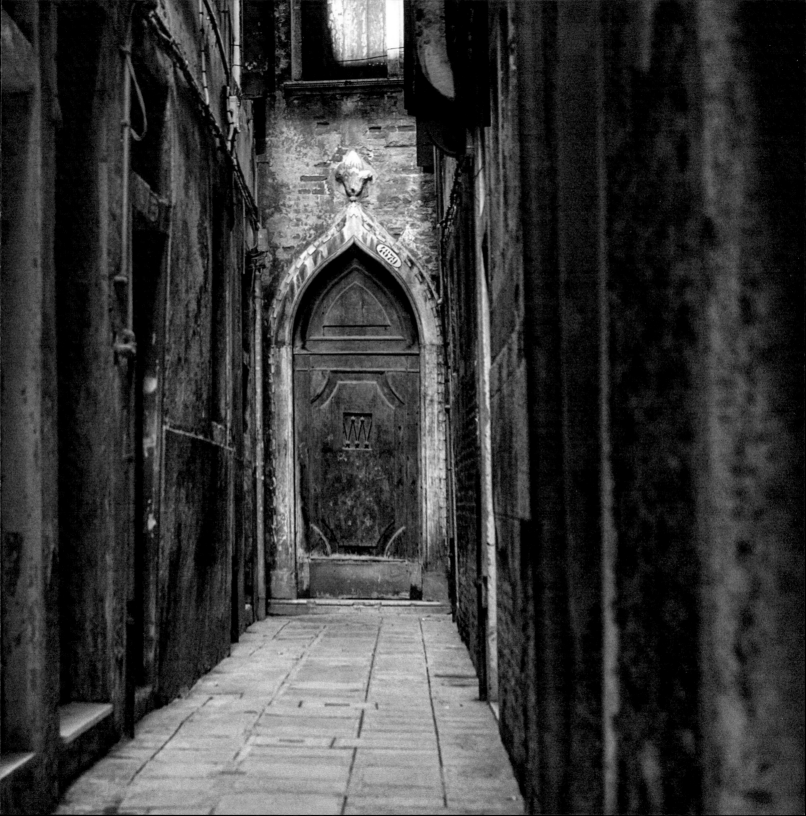

Francesco da Mosto

My friendship with Aldo Rossi began with the competition for reconstruction of La Fenice Theatre after it was devastated by fire in 1996. Meeting him in person, having studied his works, gave me the privilege of his unique point of view—a multifaceted perspective, thrown together like a mosaic of deep and highly creative emotions.

It was a strange coincidence: I had accidentally filmed the fire since we lived nearby. Then I studied the evolution and causes of that fire as a technical consultant to the official inquiry and lived inside the ruins of the theatre for an entire summer as part of the team analyzing surviving stonework.

Rossi was enlightening. We were creating something that I had lived knowing only as a place of destruction. Memories of the theatre in my youth came back to me. It was time to make it live again for what it was, and through the ideas of Aldo I discovered that his way of creating something new was in perfect communication with what it had been before. La Sala Rossi, inspired by Palladio, is an example.

He used the same approach as for the Carlo Felice in Genoa, winning the competition with "the wise use of what exists." Aldo was immediately kind, likeable and down-to-earth. He was a breath of fresh air from which spontaneous ideas and passion for thorough research were far more important than material things.

His design method was unique. His ideas arrived at the table together with a glass of wine, or came from an image drawn from a book or a film along with the atmosphere that enveloped them. His continual exploration, his motor, which rotated 360 degrees, was fascinating.

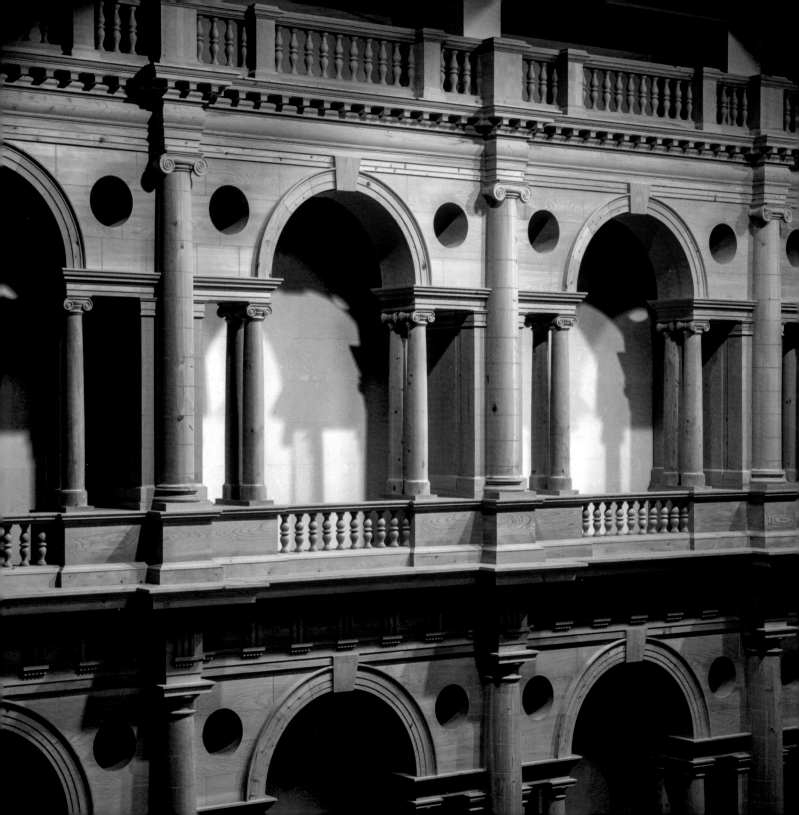

Jonathan Glancey

Both mistress and servant of its lagoon, Venice is a city of ships, boats, ferries, gondolas and *vaporetti*. The very forms of successive waves of its enticing architecture owe much to the sea. And yet, the vast majority of those who visit the city arrive today not by water, but from the air, squeezed into winged buses proffering the smallest possible views through tiny windows. On landing, the majority of visitors are then packed into coaches for the drive to Piazzale Roma, one of the least prepossessing gateways to any of the world's great cities.

And yet—but only if you are lucky enough to own or charter a light aircraft or willing to spend on a brief helicopter flight from the mainland—there is an alternative. What once was Venice San Nicolo and is now Giovanni Nicelli airport on the northern tip of the Lido is one of the world's most delightful points of arrival. It is both a few miles and a whole era away from the city's Marco Polo International Airport, which opened in 1960.

Flying to and from the Lido has always been glamorous, an experience dating back to 1911 when Umberto Cagno took to the air in a Farman II from in front of the Hotel Excelsior. The airstrip at San Nicolo itself was laid out in 1915 when French Air Force fighters and Royal Italian Navy seaplanes took on their Austro-Hungarian enemy. Rebuilt in 1935 by architects led by Antonio Nori in a singularly handsome "Italian Rationalist" style, with a hint of Art Deco, the airport brought Hollywood stars to the new Venice Film Festival; Spitfire pilots to the rescue against Nazi Germany in 1945; and, since its recent restoration, new-found glamour to the Lido. While the perfect way of arriving in Venice has to be from the sea, from the wings, the Nicelli airport plays an enticing second fiddle.

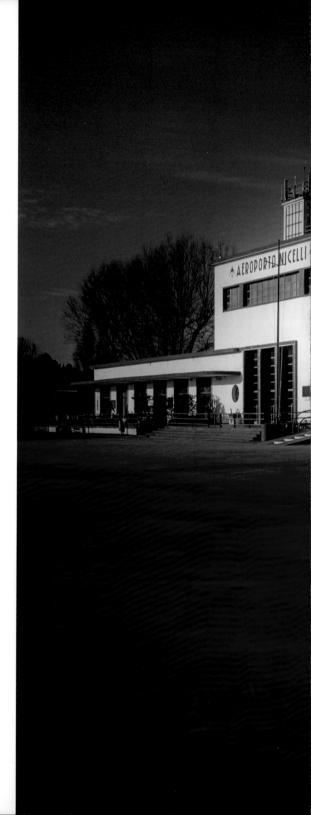

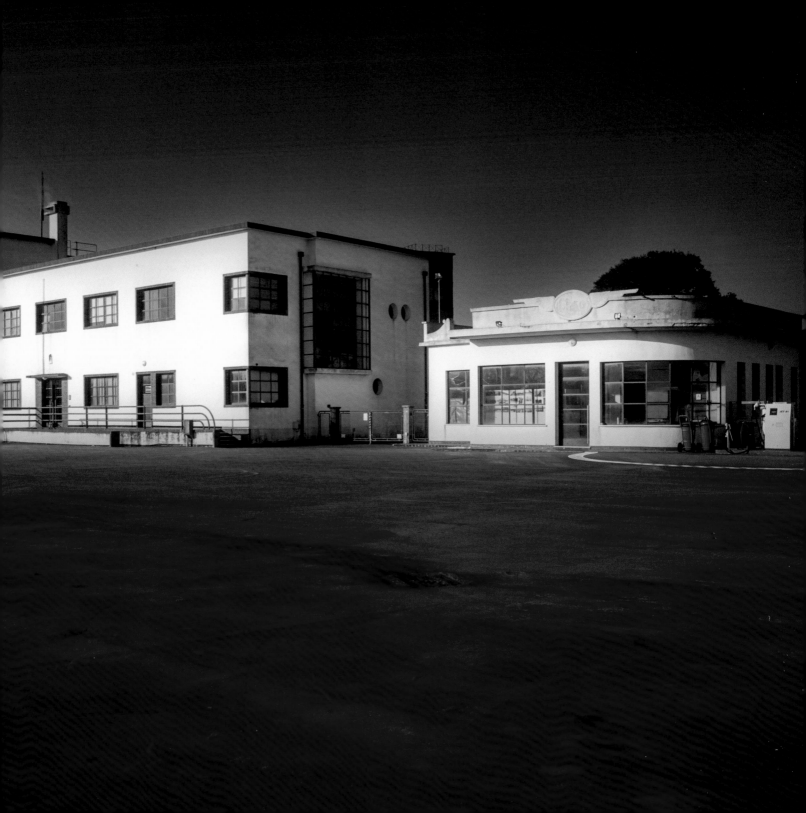

Dial Parrott

My wife and I made our first trip to Venice in late September of 1982. The weather was lovely and mild, and at night, the Piazza San Marco, lit by moon- and starlight, was magical. Entering the Basilica San Marco, we were dazzled: the ancient doges buried behind gorgeous stone slabs, the marble columns in smoky colors of green, blue and pink, the golden mosaic domes. "Beauty of surface, of tone, of detail, of things near enough to touch and kneel upon and lean against," in the words of Henry James. After several days in the city, we took a vaporetto to deserted Torcello with its pristine, awesomely beautiful medieval basilica, Santa Maria Assunta. Its small interior is one of the truly august spaces in the world.

We stayed in the least expensive room of a fourteenth-century Gothic palace known as the Palazzo Gritti-Badoer. Breakfast was served in the palazzo's splendid *sala del portego*, the principal chamber on the second floor. Light streaming through five tall Gothic windows played off the room's ornately stuccoed walls. Just inside the windows, several pet birdcages were hung above a grand piano, and these, plus the lure of crumbs from the damask-covered tables where guests were eating their morning brioche, attracted small flying birds from the square. As we sipped our coffee, birds darted through the windows, soared around the ceiling twenty feet overhead, then hopped and chirped about the rug at our feet. It was pure enchantment. Those first few days in Venice were one of the transformative experiences of my life.

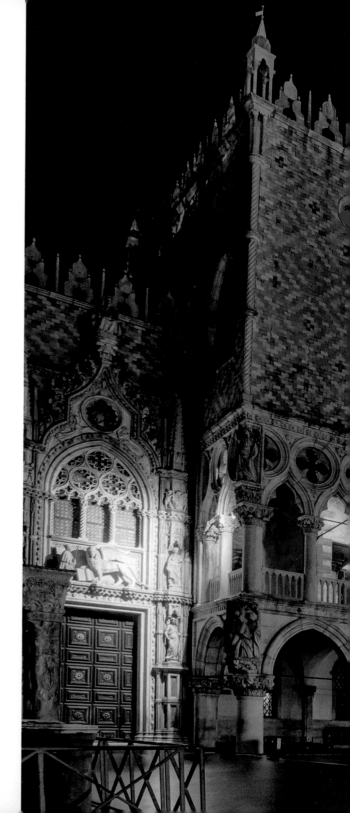

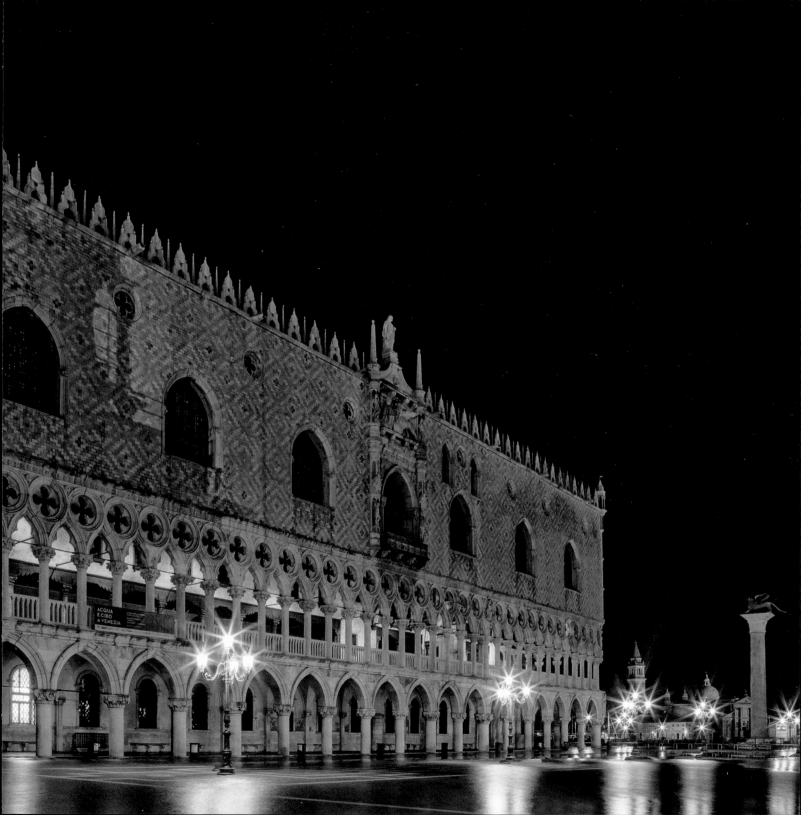

J. Michael Welton

Lost No More

I'm an eighth-generation Virginian, a fact that carries some weight in certain parts of the Commonwealth, but precious little elsewhere. It mattered even less in Venice in late September 2012. There, Virginia seemed a quaint and claustrophobic universe. Venice, on the other hand, was a dream state, totally untethered from the 21st century—which made it a fine and lovely place to get lost.

After arriving at the airport and making that long, purgatorial trudge from terminal to *vaporetto* dock, I hopped onto a waterbus. A breathtaking ride followed, past buildings too old and too wondrous to comprehend. I disembarked at my prescribed stop, seeking Philippe Starck's Palazzina G hotel, which was no easy quest. Wandering streets and bridges for 30 minutes, I finally located the service entrance to the hotel restaurant. The staff fell all over themselves. There was no signage, they said, so guests like Naomi Watts and Johnny Depp could avoid the paparazzi. "But: please—have some cake and prosecco!"

A nap ensued, followed by a visit to the concierge, who tapped the address of Peggy Guggenheim's palazzo into my GPS. I plunged into the twilight for a flaneur's 45-minute stroll, now feeling not-quite-so lost. At my destination, I ascended a stairway for a boisterous rooftop view of the Grand Canal. After a glass of wine, I slipped down to the courtyard for dinner. At dessert, I felt a tap on my shoulder. Would I like, my host asked, to tour the galleries? And, *ecco!* The Peggy Guggenheim Collection—the Pollocks, the Picassos, the Magrittes, the Mondrians, and the rest—were all mine for 15 quiet minutes until 75 guests roared in. I stepped out onto the portico. Turning left, I noted a bronze plaque, its raised letters praising the courtyard's restoration by Nelson Byrd Woltz, Landscape Architects from Charlottesville, Virginia.

It was my 60th birthday in Venice, and I was at home.

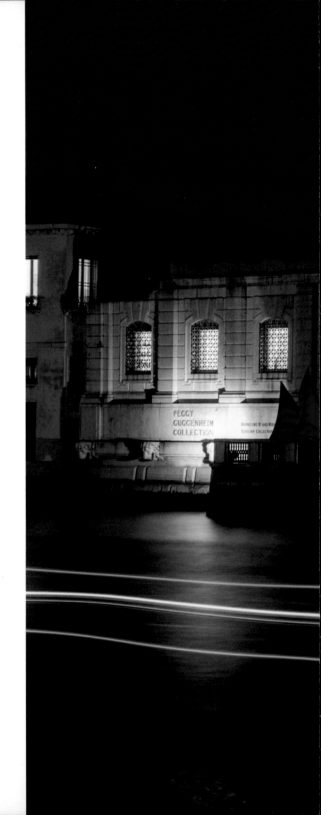

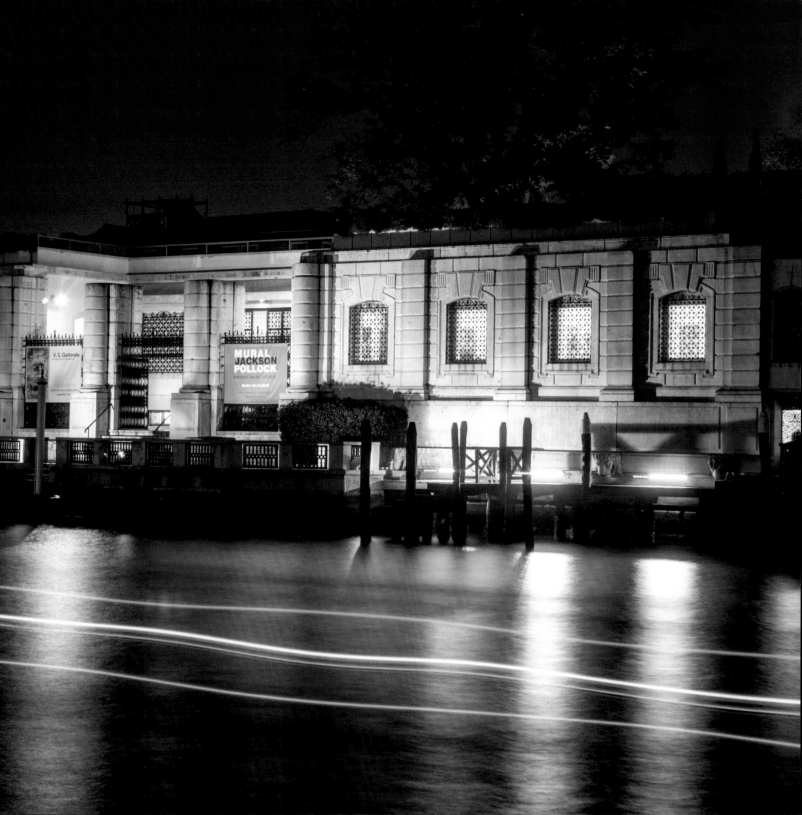

Louise Braverman

When I hear the voice of Venice, my mind wanders into that nebulous space where time momentarily stops and I am quietly propelled into an intimate dialogue with my own free floating thoughts. The voice of Venice thankfully reminds me that there is an arena in which fantasy and reality can collide, coexist, and comfortably accommodate contradictions. Venice, for me, is a metaphor for unexpected creative possibilities. This notion never fails to captivate me.

Spatially, Venice amplifies the joy of unanticipated, variegated pleasures inherent in experiencing architecture. What a delight it is to feel the opening and closing of space as you amble down a narrow, noisy cobblestone street at the canal's edge, which miraculously transforms into the enormous expansiveness of Piazza San Marco. This, of course, is always in the context of savoring a series of sensuous changes in scale—from the tiniest mosaic tile to the vastness of the surrounding sea.

Temporally, Venice embodies similar aesthetic contradictions. While it is the living history of handcrafted costumes and masked balls hiding surreptitiously behind thick, textural stone walls, it is simultaneously the contemporary global exchange of cutting edge artistic critical thought emanating from the continuous cycle of Art and Architecture Biennales.

Whether frivolous or substantial, Venice is a place where, at any moment, something mysteriously intriguing may happen. It is the native soil of an open-ended spirit of creative opportunity. Knowing that this free space exists, situates me in the expansive realm of inventive ideas that is the essence of my artistic process. For this, as an architect, I am most thankful.

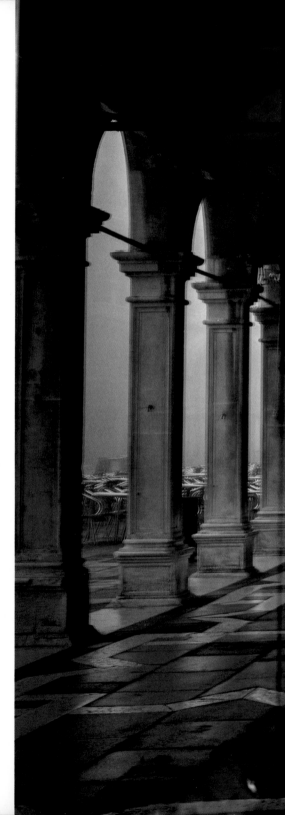

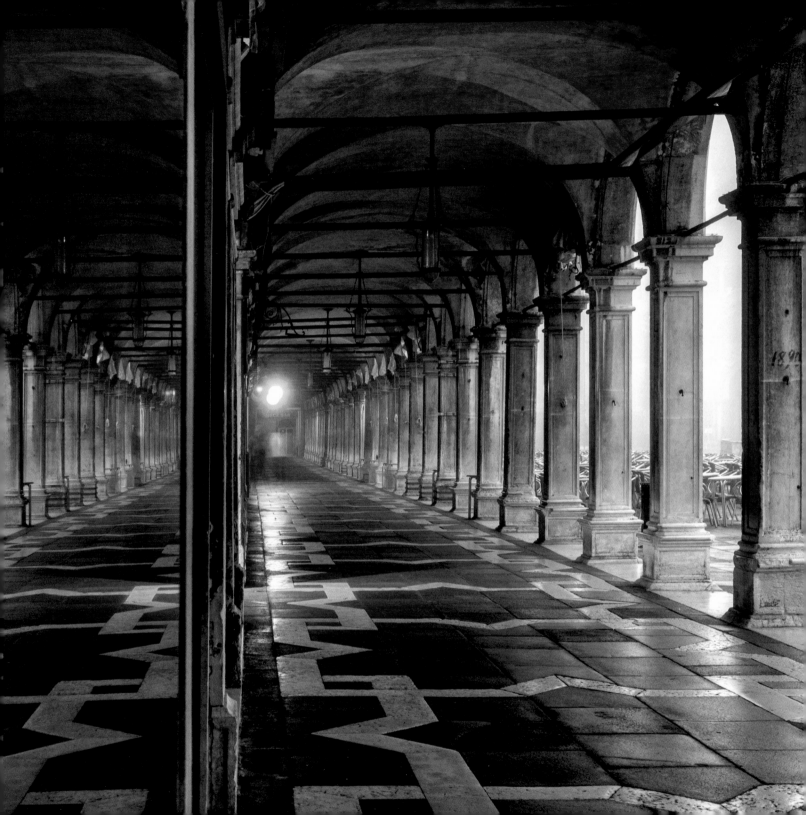

Mario Botta

More than any other city, Venice embodies a defined urban form, compact fabric and unitary body composed by successive historical transformations. Composing an extraordinary stratification of these ages and disparate cultures, Venice today presents itself as a privileged place, rich in history and memory. But the city also has a dynamic reality that the architect Le Corbusier reinterpreted in its modernity beyond its fantastic aspects. His *carnets* contain sketches, travel notes, perspective views and comments that represent his ability to grasp the more essential aspects of the urban structure. The articulation of the buildings, the plant of the monuments and the urban spaces are juxtaposed against the blueprints of the city. Through this discovery and analysis of articulations, joints between monumental elements and a compact fabric encompassing the surrounding area, the lattice of its assembly presents a rich conformation.

Le Corbusier came to explicate this heritage of knowledge, interest and attention through an unrealized hospital project. My relationship with Venice was strongly influenced by the Maestro's critical reading and by my encounter with Bepi Mazzariol, who made me physically know the city. By way of large paths, and walks along its typical *fondamente* and *calli*, he taught me to love it, to criticize it; to confront the contradictions of my work and encounters with modernity—always supported by this heritage in which he saw, to quote Louis Kahn, the past as a friend.

Because my training as an architect was completed in Venice between 1964 and 1969, I participated in a fantastic season, coming into contact with a close-knit group of intellectuals and artists who were, above all, humanists: Mazzariol, of course, but also Carlo Scarpa and the painter Emilio Vedova. Two extraordinary opportunities merit mentioning: my role as *trait d'union* between the hospital administration and Le Corbusier's Paris studio, and in assisting Louis Kahn in drafting the Palazzo dei Congressi.

I owe Venice a debt of gratitude for these—a feeling that resurfaces every time I return—as well as for my involvement in the restoration of Palazzo Querini Stampalia where Carlo Scarpa masterfully intervened. These bring a heartfelt tribute that awakens in me, a sort of repossession of these "friendly" spaces that nurtured my hopes during my studies as I awaited the challenges of the profession.

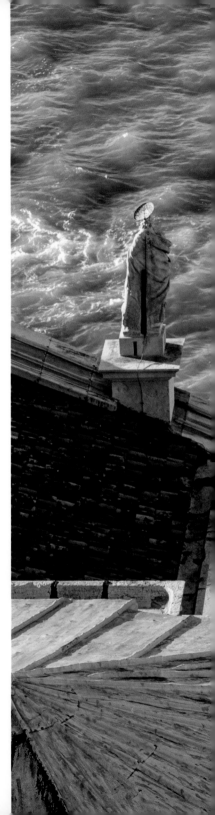

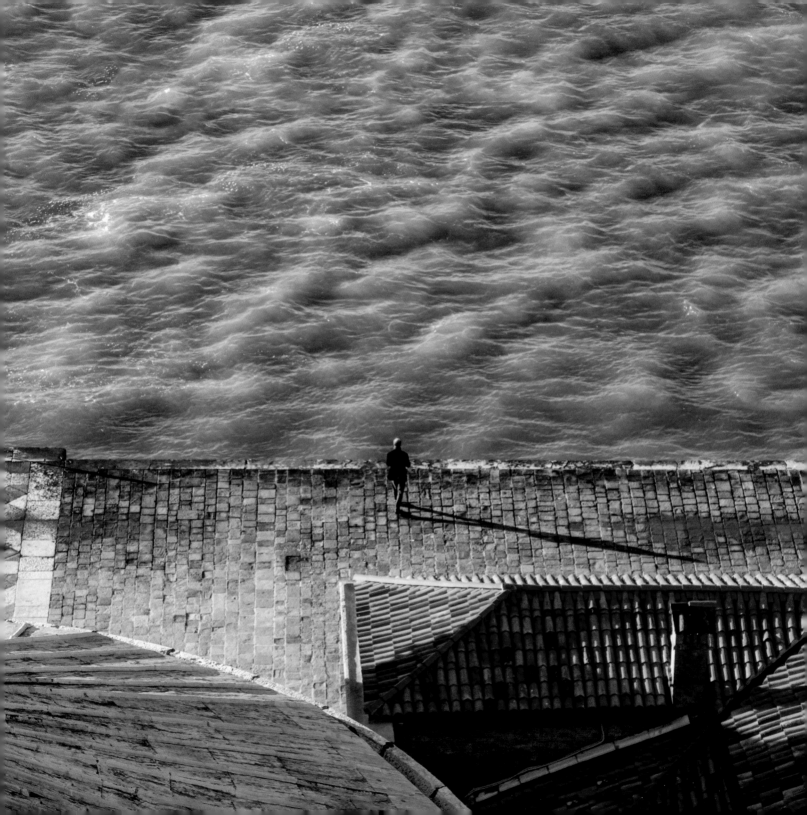

Michele De Lucchi

The island of San Giorgio is beautiful not only because it is in front of Piazza San Marco and is in the center of Venice; it is special because it is an island shaped by the greatest renaissance architects of the time: Longhena, Palladio and Sangallo.

Among the nicest things to discover are the two central courtyards of the monastery. Within the first, designed by Palladio, you breathe air of the Veneto region, the Venetian Renaissance and of northern Italy. The second courtyard, by none other than Sangallo, is strongly Tuscan; there you breathe the air of Florence, Siena and the Classic Florentine Renaissance.

On the island of San Giorgio I have restored two areas. One is the "Nuova Manica Lunga," which is probably the most comprehensive library of history of art books in Italy, perhaps in all of Europe and maybe even the world. The second area is the upper room by Palladio where the monks once ate. It has been recently renovated with the *Wedding at Cana*, reconstructed by David Lowe. The original gigantic painting was by Veronese, stolen by Napoleon and is now exhibited in the Louvre.

The island as a whole has an extraordinary *urbanistica* layout because, in addition to the two courtyards, it is crossed by short paths and lawns arranged in a pattern that has safeguarded the axial integrity of the island for many centuries. In its simplicity, this allows anyone to feel orientated on any part of the island.

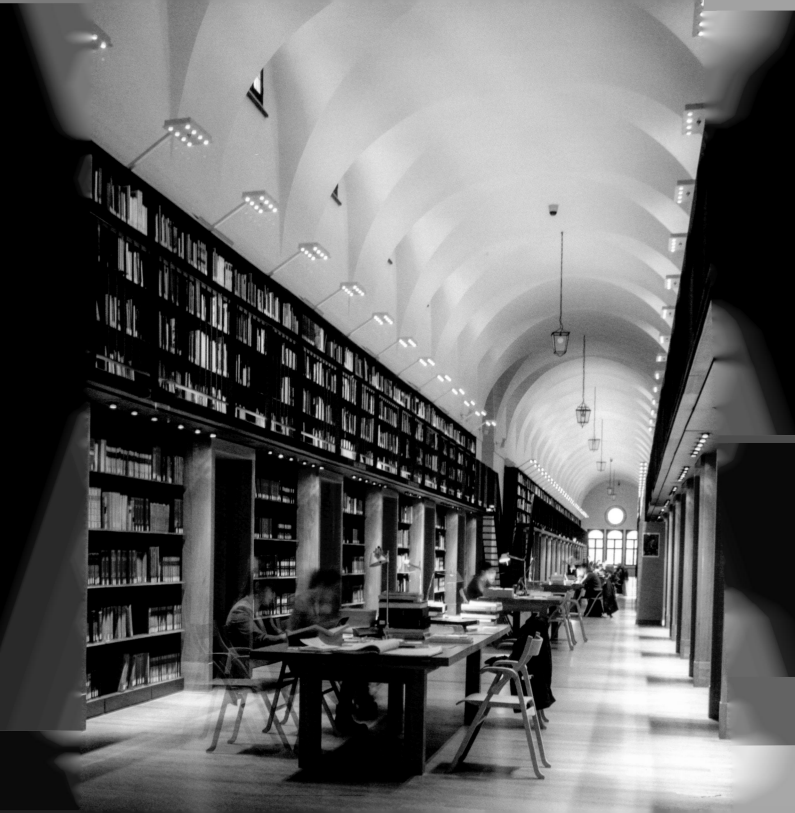

Enrico Baleri

DARK, HALF-LIGHT, LIGHT

Venice: the ageless city. How can we take measure of her to a finite time, she who is crystallized by the juxtaposition of styles, of forms, of places, of spaces...

When you walk through Venice at night, in the silence, in the darkness, the *canale* fills you with anguish, fear, anxiety, dissatisfaction, as if you're seeing a sleepless dormitory town, full of ghosts and dark clouds...

Inside the places on the ground floors you imagine unmoving ghosts reclining on large tables surrounded by chairs with the light filtering through from the outside—thus faint, so very faint, in the depths. The gondolas are moving slowly as the water laps the shore, the silver blades almost black and you think they are open funeral carriages ready for the reclining ghosts in the rooms.

At dawn the city unveils itself as the inexistent lights become real, and a little at a time, the half-light is born as the city awakens. The Venetians become excited; they become restless, almost Milanese, and chase after the omnipotent *vaporetto*. The gondolas move along the canal rippled by the motorboats, their silver blades turning into scimitars at the service of Marco Polo, ready for the battle that is the day.

The sun arrives, the full light; the city suddenly laughs—it comes to life, no longer a dormitory. You see palaces illuminated by the sun taking on an entire life of their own. The city becomes an enchantment, a dream: for the lovers on their honeymoon, for the old untarnished couples, for the clandestine lovers who take refuge far away from *terra firma*. The always few Venetian children chase each other and laugh, quietly respecting the strict rules of tourism. The Americans arrive in flashy shirts and trousers at half-mast; the iconoclastic mainland arrives, but everything becomes play and color and life.

Venice, an ageless city: who can say how old she really is?

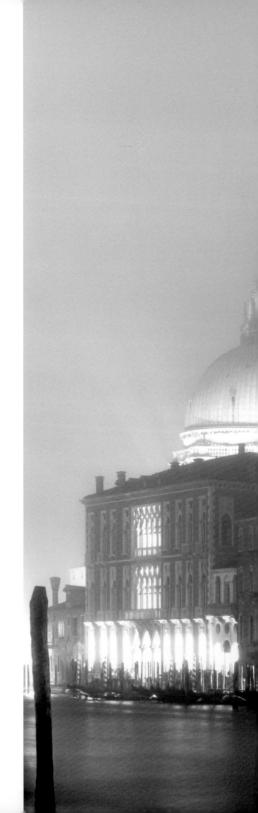

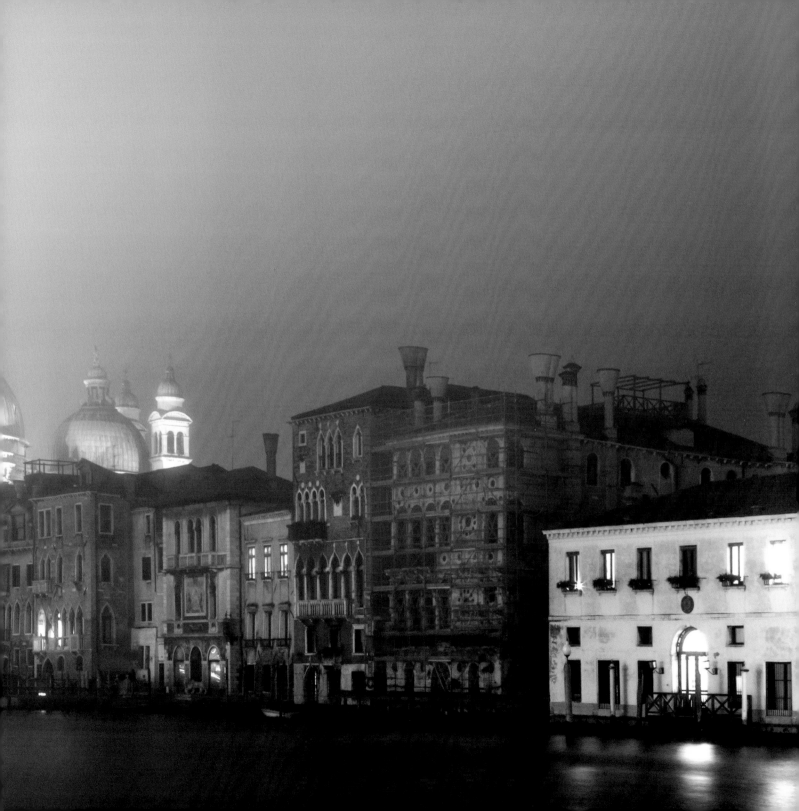

Guido Pietropoli

Memoirs of Adriano (and Carlo too)

"A business card in St. Mark's Square"—that is what Adriano
Olivetti asked of Carlo Scarpa, and his request was satisfied with an
architecture which defied time in terms of ideation and the sheer
caliber of its execution. Carlo Scarpa's Olivetti is a gift of timeless
beauty, of colors, materials and a Venetianity that makes no
concession to the vernacular. The execution took a couple of years
and Adriano became impatient, then—after a meeting at Caffè
Quadri with Giorgio Soavi and Scarpa—he understood, and being
the visionary he was, gave free rein to the architect.

Surviving a junk merchant who rented it for too much time, the
store was reborn after a careful restoration. Now from the
Procuratie Vecchie porticos, this ineffable space radiates a dream of
a tradition for modern architecture.

Venice could have walked down the path in search of a
contemporary vision of Scarpa's architecture but instead she
pursued the currency of the time rather than the timelessness of
gold. The Professional Association of Architects of the (not very)
Serenissima pressed charges against Scarpa for abuse of
profession—he did not have a degree, as neither did Frank Lloyd
Wright or Le Corbusier—but fortunately he came out the winner
and was able to present us with the great works he kept designing
until 1978.

Saddened by being reported by his IUAV students, he left Venice,
moved to Asolo and then again to Vicenza at the side of Andrea
Palladio. During the last ten years of Scarpa's life I had the privilege
of being his pupil and collaborator. One day I enquired about the
secret of Olivetti's eternal youth. Scarpa replied: "I believe
Olivetti was hard and true."

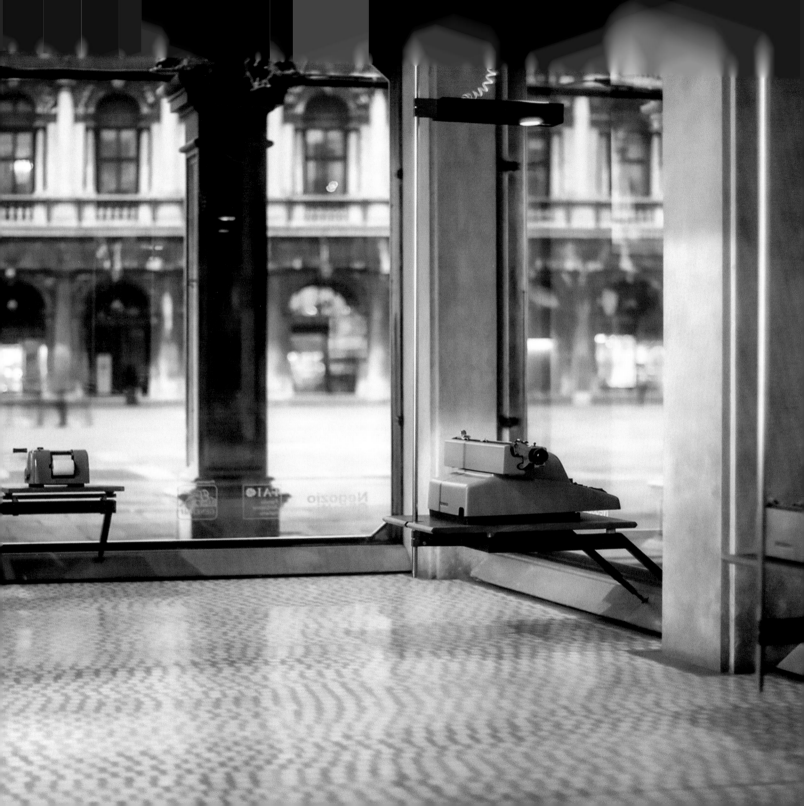

Jürgen Mayer H.

Wet Dreams

We got our feet wet. In the fall of 1979, I visited Venice for the first time. We came down from a vacation in the Dolomiti Mountains to spend two days in the city. It was the end of October, the weather turned from sunny in the mountains to rain and high flood at the seaside. While the first day was still an easy walk in the city, the second day turned into an adventure of how to find our way through the city with most of Venice being a foot under water. Elevated walks would help us maneuver through the narrow streets. And what I remember most is the Olivetti store on Piazza San Marco being flooded. I guess it was the combination of technology and the challenge of nature condensed in one small space. According to the locals it was business as usual. For me it was a fascinating moment that I now can name as "performative city." Venice's relationship and dependency on weather, seasons, local traditional rituals and international events imposes a dynamic pulse on this extreme urban life.

Only later I better understood the relationship between weather and culture. My curiosity turned into teaching design classes at Harvard, and in Berlin and Toronto, on weather and architecture as a cultural phenomenon. We try to control or even create weather way beyond managing to forecast. And we try to solve dependencies on weather with technological inventions from fireplaces and air-conditioning to flood barriers. This disconnection from weather can protect and create comfort, but it can also create phenomena like sick building syndrome. Architecture used to be designed according to local weather conditions and cities were laid out and organized according to climate and topography. Weather can provoke stress to infrastructure, and it can kick and activate our body with climate changes. Venice seems to have all of that—to extremes.

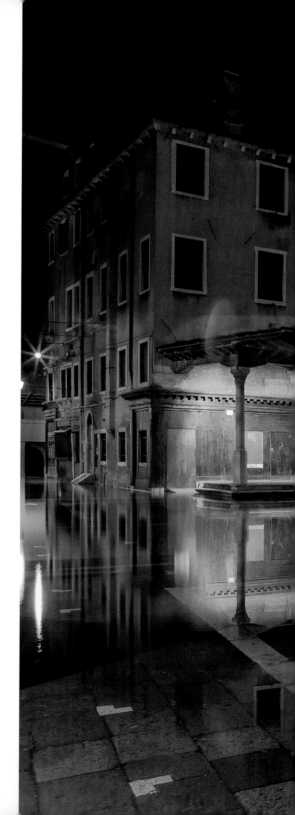

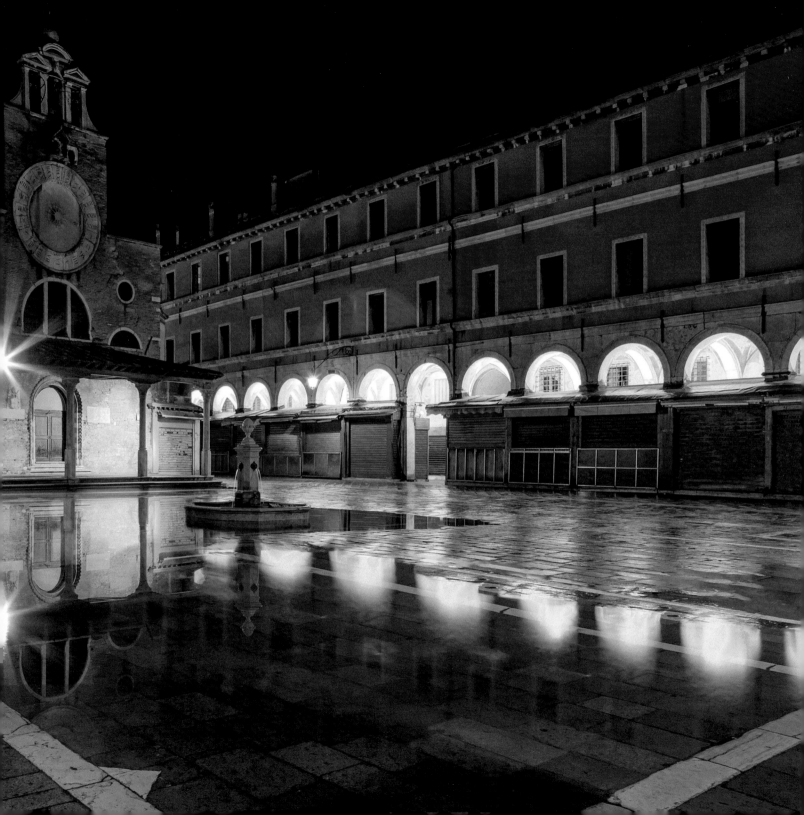

Max Levy

FORTUNA

For all its floating qualities, Venice is heavily
laden with history, stone, and gravity. Though
its marble monuments aspire artfully upwards,
they are ultimately more preoccupied with
down than up. One counterpoint to all this
weight is the prominent windvane poised
lightly atop the Punta della Dogana. This
figure of Fortune, presiding over the Bacino's
daily ballet of watercraft, pirouettes between
architecture and flight. It has for centuries
signaled the comings and goings of Adriatic
weather that tints this city's beguiling
atmosphere. For some, perhaps, it pivots to
the ebb and flow of dreams as well.

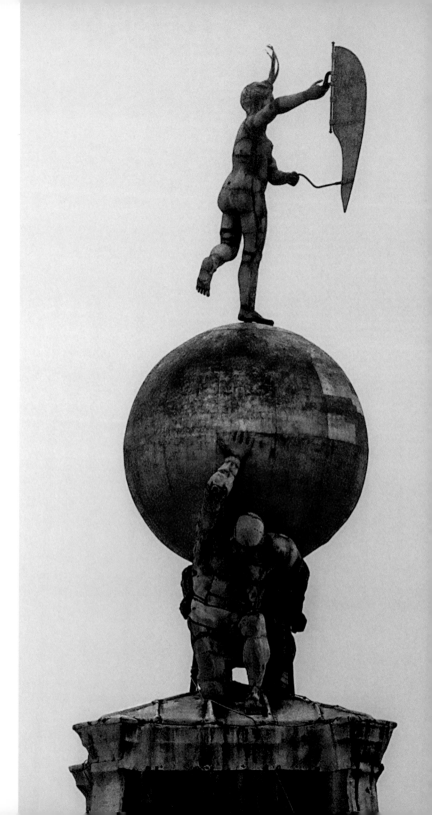

Thomas Woltz

Five years living in Venice as a young architect altered the very lens through which I see the world. The watermark the city has placed upon me is indelible—an aqueous tattoo that endures today. I came to the city to work for an architecture firm and to learn contemporary design using the ancient crafts of cut stone, *terrazzo, marmorino, scagliola* and stucco. As the years streamed by, my American frame of reference adapted to the Venetian urban form and I became metabolized into the body of the city, moving fluidly through the organs and veins of the *forma urbis*.

At times, expected spatial relationships became inverted by soaring interiors the height of forests and intimate exteriors, isolated, as Saint Jerome's monastic study. In this vein I began to realize a new vantage of the built world; I was happily living in a completely mineral landscape where urban volumes were filled with air or with water but never with meadows, woodlands, pastures or wetlands—the familiar landscapes of my wild unrestrained childhood on a North Carolina farm exchanged for the impervious ancient stones of my newly chosen Prospero's cell.

The elements of this new lexicon were stone, light, echo, shadow, mist, and fog. *Acqua alta* brought this landscape to my doorstep and misty autumnal nights challenged the safe navigation of my labyrinth; I was intrigued by my body's positive response to these materials and spaces; this was a dynamic and deeply satisfying landscape—every surface an act of design, as I now realize. Thus began my journey of making landscapes. I have now practiced Landscape Architecture for nearly 20 years and honor Venice as the grounding of my conversion.

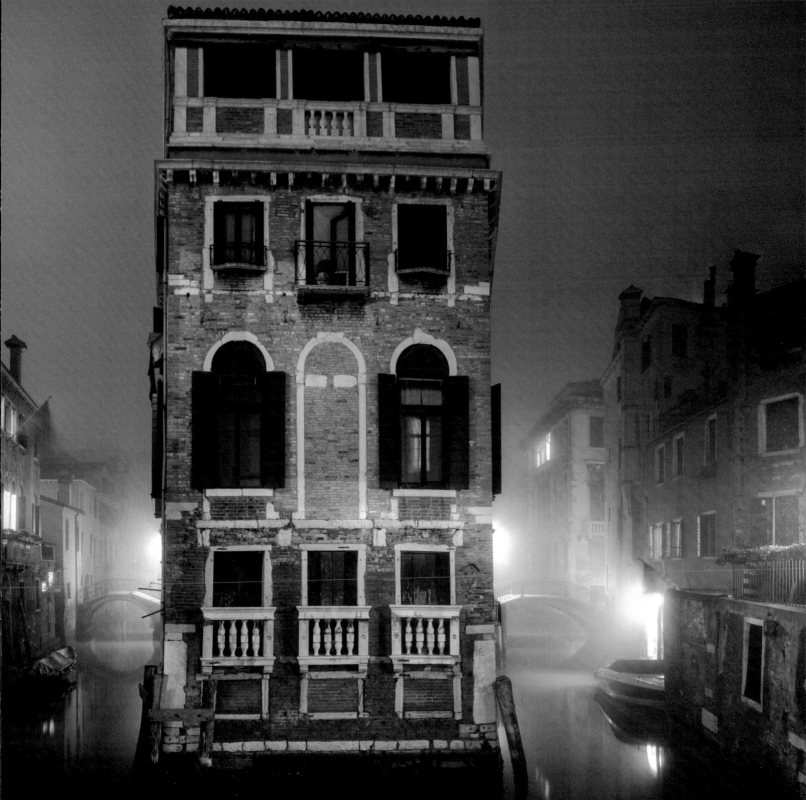

Richard Murphy

During my first visit to Italy in 1982, I "discovered" Scarpa's great project at the Castelvecchio Museum in Verona. Castelvecchio was a revelation. Inspired, I set off on a Scarpa odyssey across the Veneto culminating in Venice and, in particular, the Querini Stampalia.

In many ways that project is a brilliant abstract reinterpretation of the city of Scarpa's birth. In the garden, the exposed concrete walls, encrusted with a line of luminescent colored glass tiles, precisely describe the ability Scarpa had to take a base material and transform its entire status; indeed, a Venetian tradition that Ruskin would have immediately recognized.

Fast forward thirty years and while designing a house for myself in the heart of Edinburgh's historic New Town, I decided to make a little roof terrace as a homage to that beautiful garden. I tracked down the Venetian manufacturer of the tiles, and entering their glassblowing and mosaic workshop, I felt like I was walking into a mediaeval world.

In their new home, the tiles now sit in their concrete walls of identical specification complete with watercourses. However, only now do I understand Scarpa's fascination with them and why he used them first at the Querini Stampalia and then in many subsequent projects. Every day brings surprise and a delight when seeing how light—even our misty grey diffuse Scottish light—can bring the tiles to life. There are times when they seem to leap off the wall, when they cast golden rays on those who are nearby or suddenly reflect a passing color back again. They truly have a life off their own—a little piece of Venice that has floated into an Edinburgh New Town garden, and a permanent and ever-changing reminder, in this northern place, of that astonishing golden city.

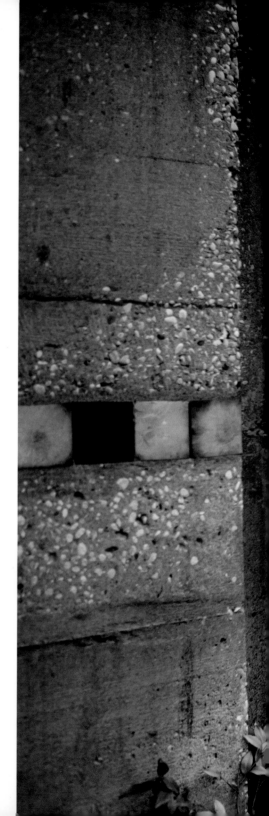

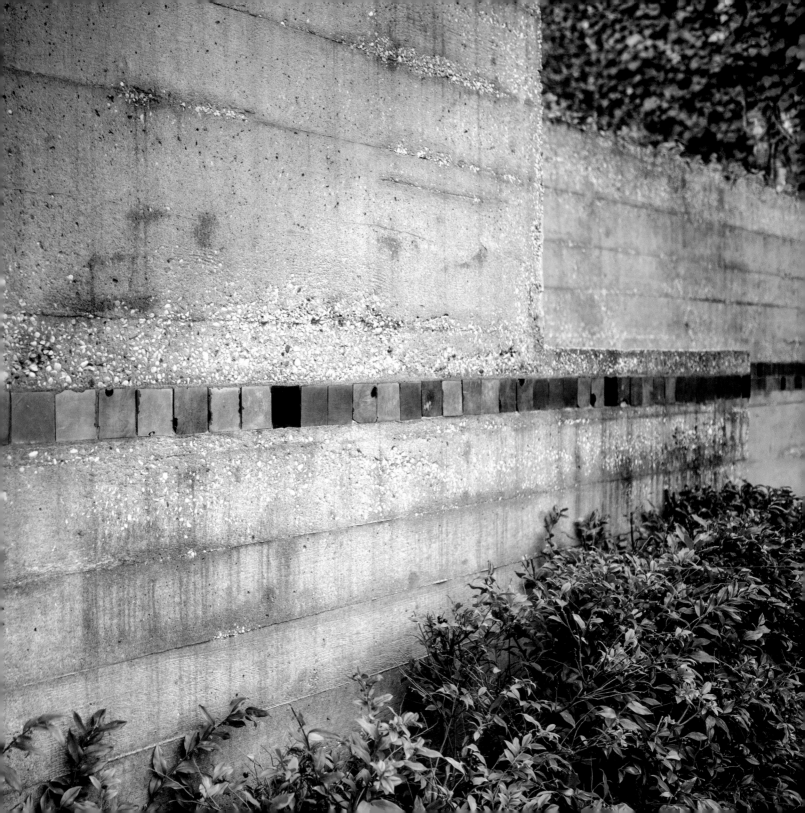

Randy Bosch

Of all cities, Venice is my paradigm. She responds to millennia of necessity with inspirational creativity. Her architecture is the container of profound experiences, lives and loves. She engages all senses, celebrates action, embraces innovation and, intentionality, shuns tyranny and tolerates hubristic Modernism in art.

An architect's informed mind expects inspiration at every turn in Venice, until an enigmatic *sotoportego* looms ahead. Passages connect interests and places to allow communal celebration of life in buildings and cities. *Sotoporteghi* are usually narrow, twisting, dark and mysterious tunnels bored through ancient existing buildings. They conspire with crooked bridges and offset streets to link islands never intended to join. Afterthoughts that stitch together the Venice quilt, their use seeming an unavoidable penalty paid to enter wonders reached only through them.

Seeking recovery from the darkness of devastating disability, artist Pierre Case overcame fear of unknown experiences and uncertain outcomes by exploring 240 sotoporteghi. The revealed mysteries of passage leading to light and life at their ends rekindled joy, artistic inspiration and his epic work, *Misteri del Sotoportego*.

Sotoporteghi are palimpsests, mental and physical images of memory and history scraped away to reveal truths forgotten or new; refreshed fabric on which to restore life, to inspire art and architecture.

Henri Bergson wrote, "The eye sees only what the mind is prepared to comprehend." My passages through the sotoporteghi continue, now celebrated with open-eyed anticipation because of Case's revelations. They inspire my work. No aspect of design can ever be simply necessary or tolerated again.

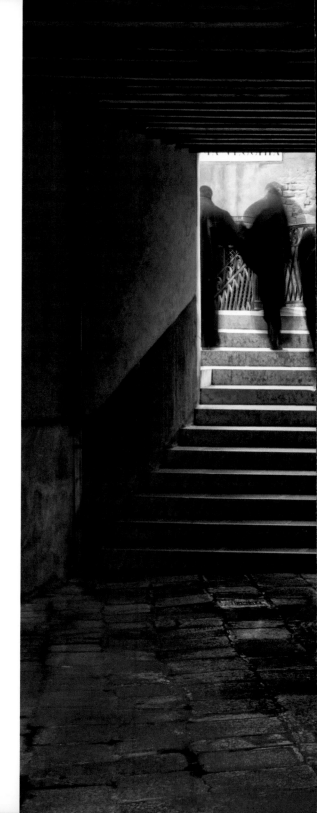

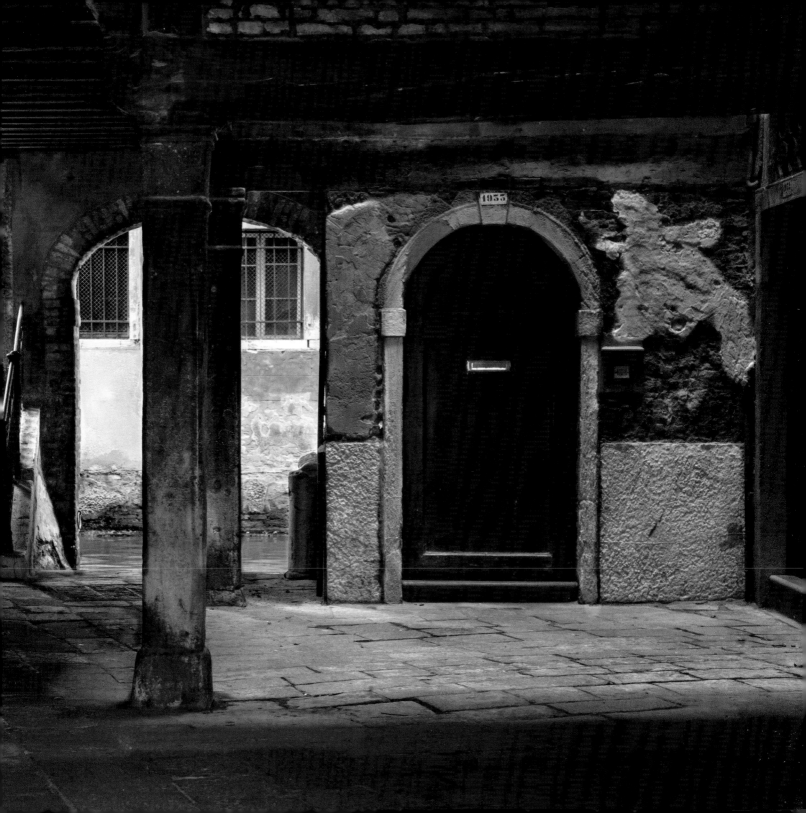

Michael P. Johnson

Carlo Scarpa, the consummate architect, and Venice cannot be separated. He was born and lived most his life in this magical city floating above the water that connects it to the landmass of all cultural history.

Each day, week, month and year, architects from throughout the world embark on a sacred pilgrimage to Venice to pay homage to this great Venetian and to study the work he has built in this historical city.

Not more than one hundred meters away from the Biennale Giardini, the sea envelops a monument to the *Female Resistance Fighter*, which is embraced by a platform designed by Scarpa. Italian artist Augusto Murer created the exceptional sculpture, a tribute to war-felled women.

What, one would ask, is the importance of this small project given the magnificence of Scarpa's body of work? I contend that architects have the responsibility to speak out against unjust human behavior exhibited in the world we occupy. As did many of the Italians who, along with Bruno Zevi, along with Scarpa, spoke out and fought arm-in-arm against the fascist rule of their homeland. To quote Brazilian architect, Oscar Niemeyer: "Architecture will always express the technical and social progress of the country in which it is carried out. If we wish to give it the human content that it lacks, we must participate in the political struggle."

Each visit to Venice finds me at Harry's Bar to unwind from the intense emotional involvement of the day breathing in the beauty and culture of the city. I see myself sitting with my old friend Zevi, discussing the importance of Scarpa's canon of work. In walks Carlo, joining us in a drink of scotch…Three old goats reminiscing about the architectural wars and fighting the good fight.

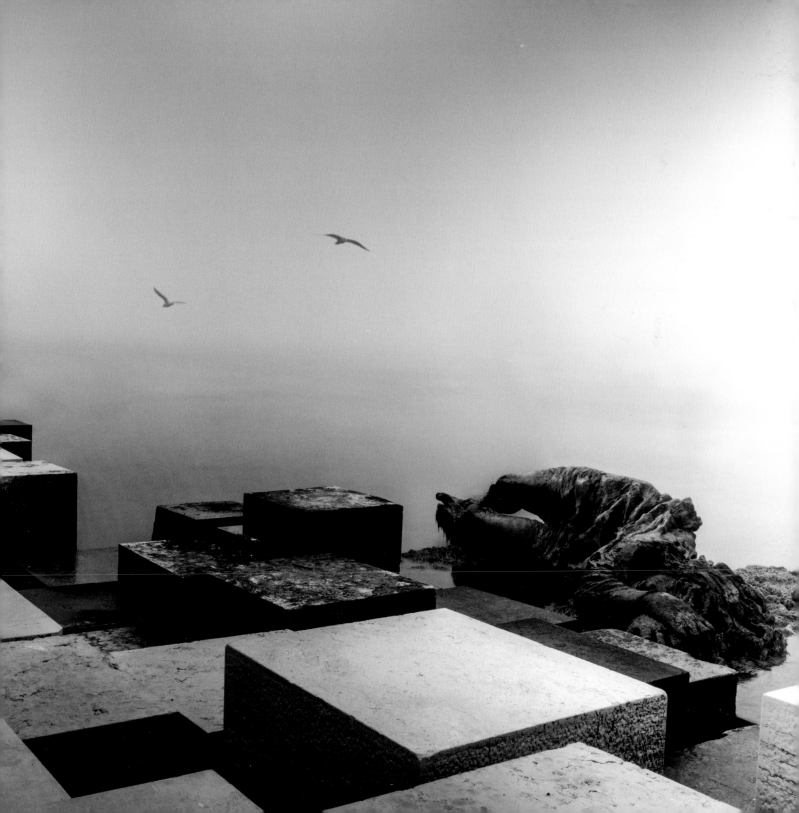

James Biber

While it is hard not to love all of Venice, I most love the Venice of Egle Renata Trincanato.

Her exquisite drawings plumb the relationship between the grand and the modest, between houses and housing in Venice, while exploring the extraordinary rationality behind the seemingly picturesque city. The hidden dimension revealed in her 1948 book, *Venezia Minore*, is as ruthlessly modern and efficient as any developer today but with a Palladian sense of proportion, scale and elegance.

Celebrating the commonplace can be a tiresome, or at least a quaint exercise, but with Trincanato the underlying structural relationships between the *palazzo*, the *casa* and the *casetta* are clarified, having the effect of making every Venetian building a study in grandeur. This may be at odds with our love of the worn, layered, sagging relic that Venice presents today. Her book forces us to confront the precision and intentionality, the complexity and the logic of Venetian living.

This seems to me to be the essential contradiction of Venice—a place of romance that is as cool and calculating as surgery with its picturesque facades masking an unmatched sophistication of plan and circulation; a city that appears to be a relaxed tourist-driven playground while it is in fact a well-tuned machine struggling against incredible contextual odds to function with a sense of normalcy. The illusion of ease and simplicity is an Italian trait, but in Venice it is high art.

Trincanato's hand-drawn elevations, plans, perspectives and renderings are a seemingly casual sketch of midcentury Venice, but are in fact a highly ordered survey of the city from the well known to the vernacular, all imprinted with the signature of its most acute observer.

I love Trincanato's Venice because I see it as a Venice stripped of superficial beauty while revealing its deeper allure. Italo Calvino describes a Venice that is magically everything and everywhere; Trincanato describes the hidden intelligence of Venice exercised over centuries.

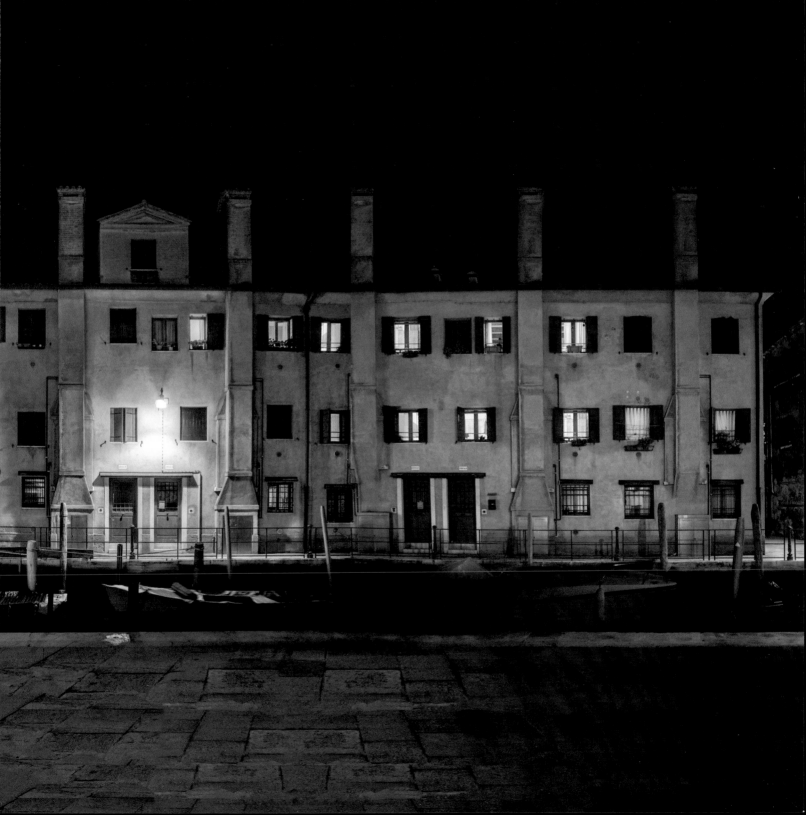

Cynthia Davidson

The first time I saw Venice my hair was long and my skirt short—the hair long enough, and blonde enough, to attract two Italian soldiers on holiday as I was strolling along the sun-splashed Lagoon; the skirt far too "mini" for the decency standards one had to meet to enter the gilded realm of St. Mark's Basilica. That night, the soldiers somehow tracked my brunette friend and me to our student hotel in Mestre and noisily tried to break into our room. The next morning, sleep-deprived and wearing a borrowed modest raincoat, I returned to St. Mark's and the quiet of its sanctum.

For twenty-one years, those were my vivid memories of Venice. Not the exotic Moorish architecture, not the deep darkness of the *calli* at night, not the canals awash with motion. Then I made the second of what is now many visits. Too warmly dressed in a white tuxedo shirt and a pair of black velvet leggings, I sweated through the September parties for the fifth Venice Architecture Biennale, but as I waited for the *vaporetto* at the Giardini stop, the sound of every wave slapping against the *fondamenta* was like a soothing mantra. Though water can be cruel, that day it cast a spell.

Venice may be too hot, too cold, too humid, too crowded or too easy to get lost in, but "her streets, through which the fish swim, while the black gondola glides spectrally over the green water"—as Hans Christian Andersen eloquently stated—release us to imagine alternatives to the general standard of urban living. Venice is not *on* the sea but *of* the sea, eclipsing the tale of Atlantis with a modern mythology both repeated and rewritten with every tide.

Shun Kanda

Within the Labyrinth

Venturing into Venice is akin to an intravenous journey through meandering passages of a city conceived upon virtual ground. Our eyes and feet scan the topography of this haptic vascular maze, soon finding ourselves moving sideways in sync with the interlaced cadence of *calli, campielli* and *canali*. In time, we succumb to the city's seductive breathing labyrinth.

How unsurprising then that on one spring day, I found myself unceremoniously sliding into Chiesa di San Canciano without ever having viewed its façade nor its edificial presence. I was like a child drawn into a mother's beckoning arms. Not a frontal arresting embrace but a gentle "come this way, inside."

Entering the side portal, I could see another opposite. It was a passage transecting the narthex, paralleling the street outside, an interlude offering temporary detour—a momentary choice crisscrossing the world of the sacred and the profane.

The architectural genius of this spatial disruption lies in the uninterrupted slice of urban passage suddenly interiorized—held as it were, in a protective bosom within the labyrinth.

The paired side doors invite the community in, pulling the once bustling canal-side activities at Rio di S. Apostoli, from Campo S. Maria Nova, at the other end. In true Venetian form, this church exquisitely unites the city's *acqua e terra* duality. The church, presumably founded in the 9th century by fugitives from Aquileia, demonstrates a critical lesson of organic urbanism, which I have repeatedly essayed.

Chiesa di San Canciano proffers a disruptive joy—a quintessentially mischievous exemplar defying normative Euclidean logic, as is all of Venice. In the end, anxious passages embedded in the Venetian labyrinth and liberated insights within it, become one. For this, I find myself returning to this non-rule abiding city.

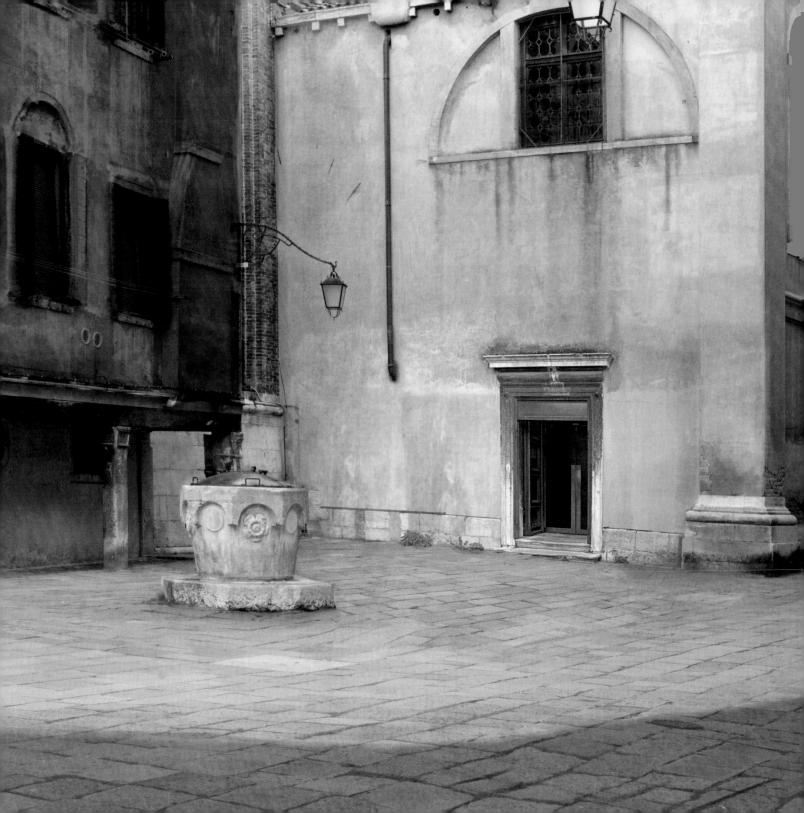

Vincenzo Casali

I met Carlo Scarpa while I was studying with his students and collaborating with his extraordinary artisans, who literally flooded me with anecdotes about him. He is an author who does not endure the cumbersome presence of the past, believing that in addition to having dignity, he has the duty to be at the level of his predecessors. Scarpa has expressed himself with the original language of his time, which took from the past both technique and understanding, though he did not passively repeat its voices. It is the most authentic testimony to what Venice is: a city of the contemporary.

Venice, through Scarpa's work, reveals itself to be a place where it is possible, natural and necessary to invent a future for itself. It is even so today, notwithstanding the flattening of a conformist vision that wants to "sell" Venice as a representation of what it once was—a city of nostalgia, remembrance, memory, melancholy.

Venice, instead, is an extremely alive city faced with the pressure of global tourism that it shares with other important historic cities. Next to the shops selling low-cost items, the ateliers of the artisans are still active—gilding and engraving, fusing bronzes and weaving fabrics, metalworking and glass blowing, they are constantly updated to deal with new production and the ever-greater sophistication of the techniques of restoration.

Many small Venetian restaurants whose cuisine proposes again classical dishes made with local produce that comes from the islands and nearby farms compete with the multitude of very low-cost restaurants spread along the beaten track. Constant cultural events are of highest profile: concerts, Venetian and international artists' exhibits at schools and art galleries, debates, poetry readings. Everything is right before our eyes. In order to notice, all we have to do is walk with a different pace—like a Venetian: a little faster. We have so many things to do.

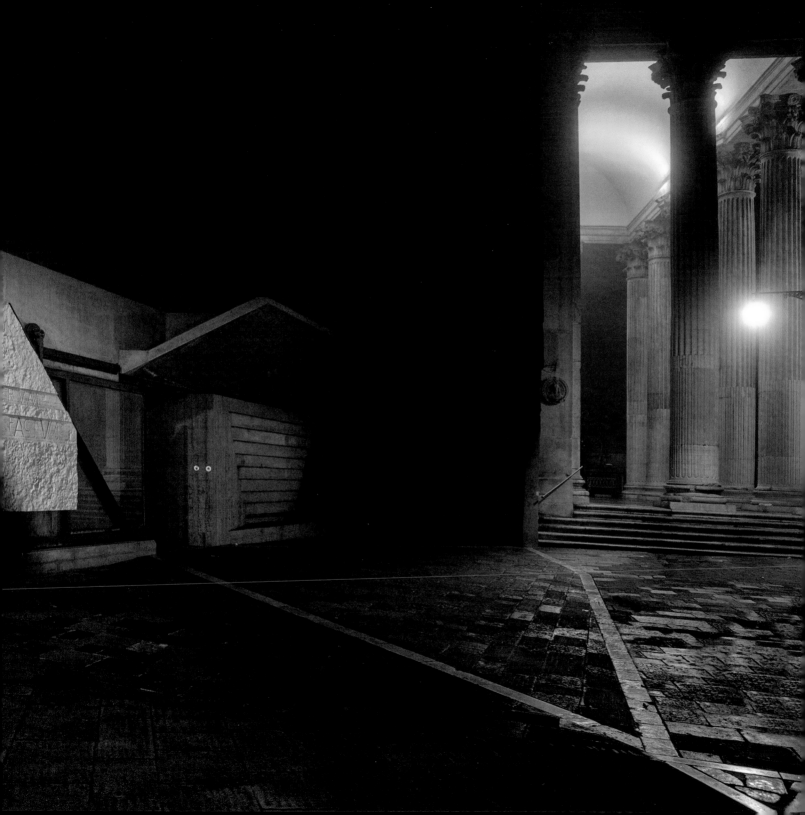

Witold Rybczynski

The Palazzo Pésaro degli Orfei, not far from the Piazza San Marco, is not as notable architecturally as the Ca' d'Oro but it has a different—and for me a far more compelling—distinction. For fifty years, most of his adult life, the great Spanish-born designer Fortuny lived and worked here. The building, which dates from the fifteenth century, has been renovated but when I saw it thirty years ago, it was entered through a dark courtyard with peeling plaster and stained marble. A fragile stair led to a moody interior that was crammed with an assortment of strange and wonderful stuff. Not a museum exactly but someone's home, an unusual someone with broad and varied enthusiasms.

Mariano Fortuny (1871-1949) was a painter, photographer, and stage designer. He invented new types of theater lighting—his lamps remain in production today—and he developed a method of block printing velvet and silk (the Fortuny fabric factory still exists on the Giudecca). He was one of the twentieth century's great fashion designers—his hand-pleated, body-clinging, jewel-toned gowns are at once simple and seductive, modern and ancient. To Marcel Proust they suggested, "Venice loaded with the gorgeous East from which they had been taken."

The main facade of the Fortuny *palazzo* faces the Campo San Benedetto. It is adorned with the characteristic ogee arches of Venetian Gothic, a classification of the Gothic architecture that originated as an ecclesiastical style in northern Europe where it can be dour and forbidding. Venetian Gothic is neither. Adapted to residential construction and suffused with Byzantine and Moorish influences, it is light, graceful, and whimsical—almost feminine. The right setting for the fashion maven who was known as the "Magician of Venice."

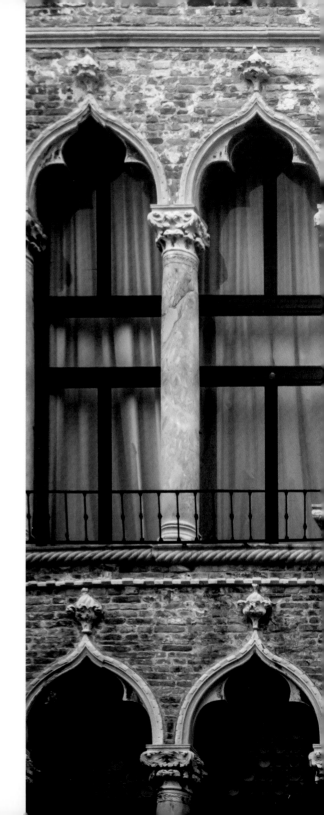

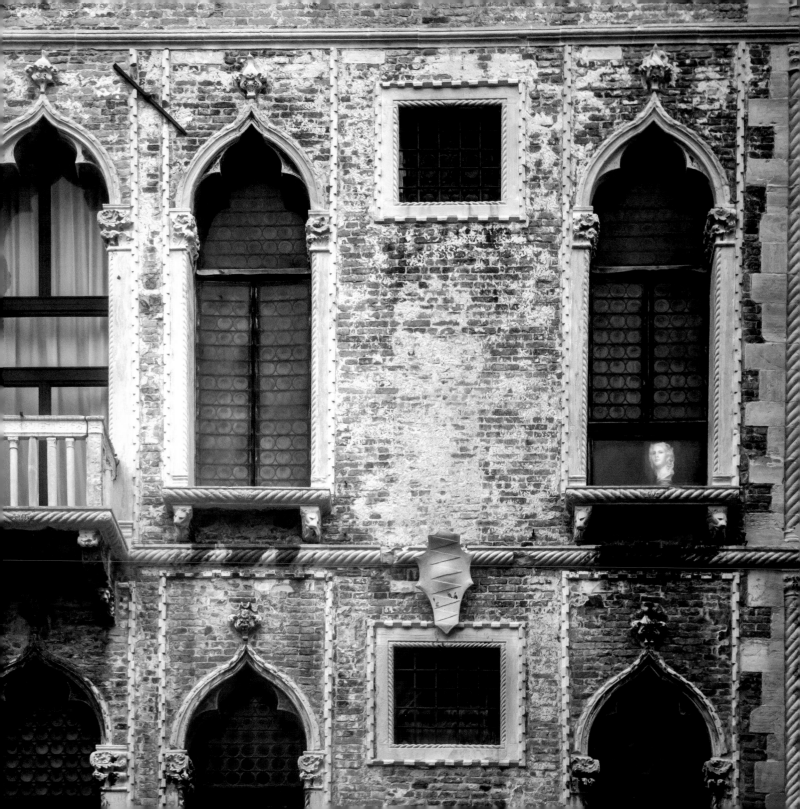

Massimiliano Fuksas

In the work *Marinaio* by Pessoa, the second guard—in order to help pass the night—tells the story of a sailor, who shipwrecked for a long time on a desert island, feels the need to build himself a homeland, for he had very few homelands.

He builds one in his mind...beginning with imagining the landscape, then the roads, the squares and then every detail, even to the point of imagining the inhabitants of his new homeland.

This process takes for granted that the concept of a city or a neighborhood has its origins not in architecture, from a construction or a city planning prospective, but from the landscape. This way of configuring a city from a writer's perspective is nonetheless surprising. For the architect, the recognizing of a city is nearly always expressed through emerging elements: a bridge, a monument, a tower, a neighborhood or a geometric structure. In the end, nearly all of us reason like collectors of snow globes, those that are found in all souvenir shops, and show the stereotypes of different cities.

It is rare that landscape is used as the substantial element of a city, its GEOGRAPHY. But Venice is the exception.

To picture her, let us begin with the waters of the lagoon that have the acrid taste of stagnation with its saltiness that penetrates with the humidity, arriving at the Lido, and finally, to the sea—the real sea, the one that changes and alters, and frightens less than the high or low tides that violently shake the city. Venice, within whose waters everything that there is to reflect is reflected, including history. Venice, where everything flows, unpredictable, like nature itself.

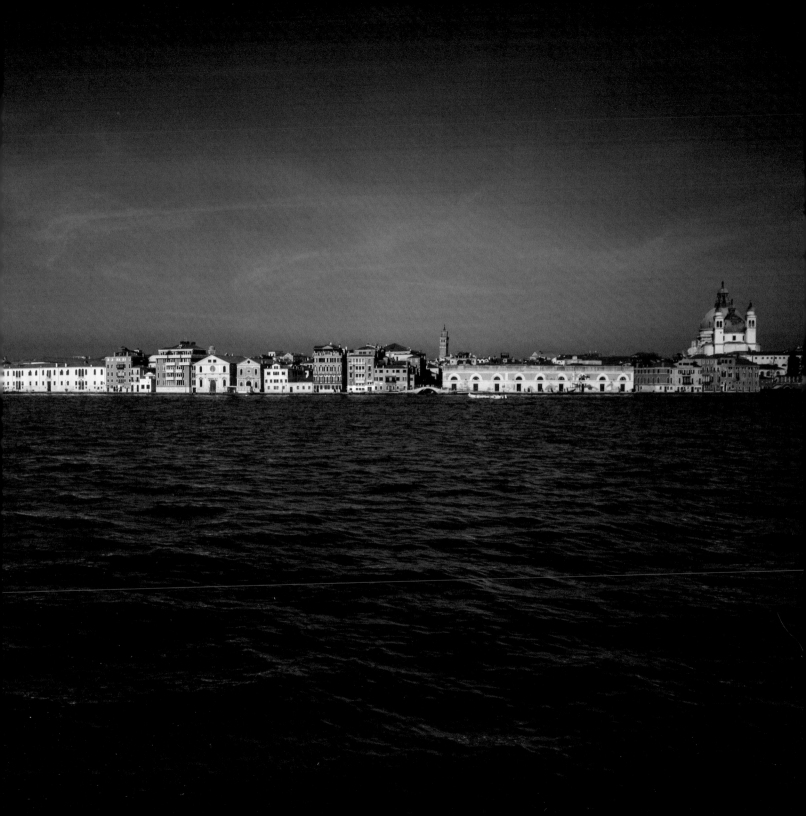

Rocco Yim

Like every schoolboy, I was dazzled and enchanted by Venice when I first visited the city after leaving college. I have returned several times since. Somehow my enchantment with the city hasn't much abated and I am just now beginning to discern why it lasts.

This enchantment is not so much with the architecture, although there are obvious gems everywhere—both classical and contemporary. It is not really about the canals. There are equally enchanting waterways in central China where water and buildings fuse poetically and seamlessly. It is not about the Piazza and squares, as similarly exquisite and diverse public realms exist in most traditional European cities.

I am enchanted by Venice because this city keeps enticing me to get lost, prompting renewed exploration and discovery every time. It is a city that does not offer clear orientation and direction at a glance so it requires effort to comprehend. Yet every time you get lost in its labyrinth of alleys, passages and waterways, you will somehow always reconnect with something familiar after a while—a glimpse of the Grand Canal, an intricate façade, a landmark bridge...

This element of spatial surprise is one major source of inspiration for me when I embarked on the concept design of the West Kowloon Cultural District in Hong Kong in 2010, for which I proposed an intricate multi-dimensional odyssey of public domain rather than set-pieces of iconic architecture, the former intended to be the soul of the District that will prompt continual exploration and discovery, ultimately attaining a sustained vitality, much as Venice has done over the centuries.

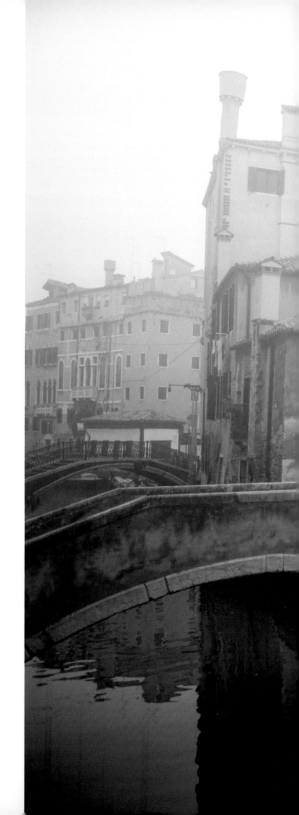

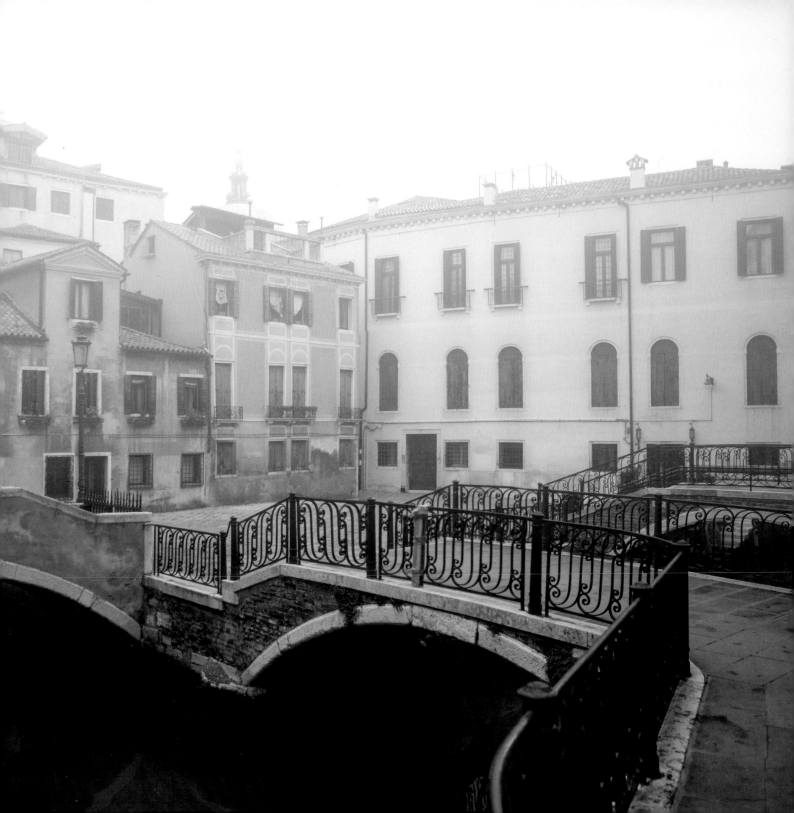

William Menking

At the 2008 Venice Architecture Biennale, the façade of the United States pavilion was covered with a silk-screened image of the Mexican American border—steel poles descending into the Pacific Ocean. The banner was a favorite of the Italian Carabinieri, who are always strategically placed for security near the U.S. and adjacent Israeli pavilions. They explained that they understood immigration and applauded the American decision to protect its border.

Aaron Levy and I, as co-curators of the 2008 U.S. pavilion *Into The Open: Positioning Practice,* hoped to use the syntax of Venice's centuries-old simulative visual power to encourage a new way of thinking about art and architecture. We intended the banner to depict the complex relationship that exists in border spaces, as well as the power of design to separate people and question the contemporary nation-state. The reaction of the Carabinieri forced us to rethink how architecture should be displayed, particularly in Venice. The passage from the center of Venice to the Biennale is one of the most spectacular in the world and powerfully affects how viewers look at the exhibition. In 2008, the Sospiri Bridge was covered with an enormous sign by the automobile maker and at the vernissage, the Italian Northern League held a rally in the front of the exhibition's entrance.

Cities are products of human endeavor. The Giardini is built on an ash heap but as Venice makes abundantly clear the "spectacularity" of the city masks this reality at every turn. Architects and Biennale curators of architecture have to acknowledge the seemingly inexorable desire for spectacle but not forget, as Paolo Portoghesi says, "architecture is for the public" and possesses the possibility "of direct communication between people and architecture."

Valeriano Pastor

The subjects of the musical meditation *Algario, 2013, A Small Underwater Anthology for Clarinet, Viola and Percussion* by Claudio Ambrosini are fifteen types of algae that grow in the Venetian Lagoon. The anthology begins by evoking rowing between sandbanks, a movement the composer presents in a modern form. Ambrosini, who was awarded the gold medal during the 2007 Biennale, suggests that listening to the piece while viewing the botanical images projected on a screen will help to develop the understanding of sonority.

Few people know of the fifteen types of lagoon algae and fewer still could say their vernacular names (Ambrosini himself had fun making them up). But we in Venice are aware of their existence and recognize their importance within the lagoon environment. The invasion of other parasitic species concerns us, demonstrating the codependence between Venice and the Lagoon. Algario's metonymic representation recalls and renews this historic unity.

Another poetic example of unity is *architecturally sung* by Carlo Scarpa at Querini Stampalia. Here, the administrative committee and the director Giuseppe Mazzariol asked Scarpa to address the problem of *acqua alta* that was too frequently disrupting the activities of the Foundation, library and museum.

Scarpa responded with a project that appears to have been elaborated with otherworldly detachment by designing internal channels along the perimeter of the floor, capable of safely receiving the water that routinely exceeds floor-level in the entrance hall.

Scarpa goes straight to the heart of it, exalting the poetry inherent in the natural phenomenon while befriending its aggressive action. It is a metonymic model—wonderful in itself—of the Venetian Lagoon system. His hope, in the transition to a larger scale, is that it will be grasped in its conceptual beauty. This, too, invites a choral meditation on other serious environmental changes. Will we understand the meaning of it?

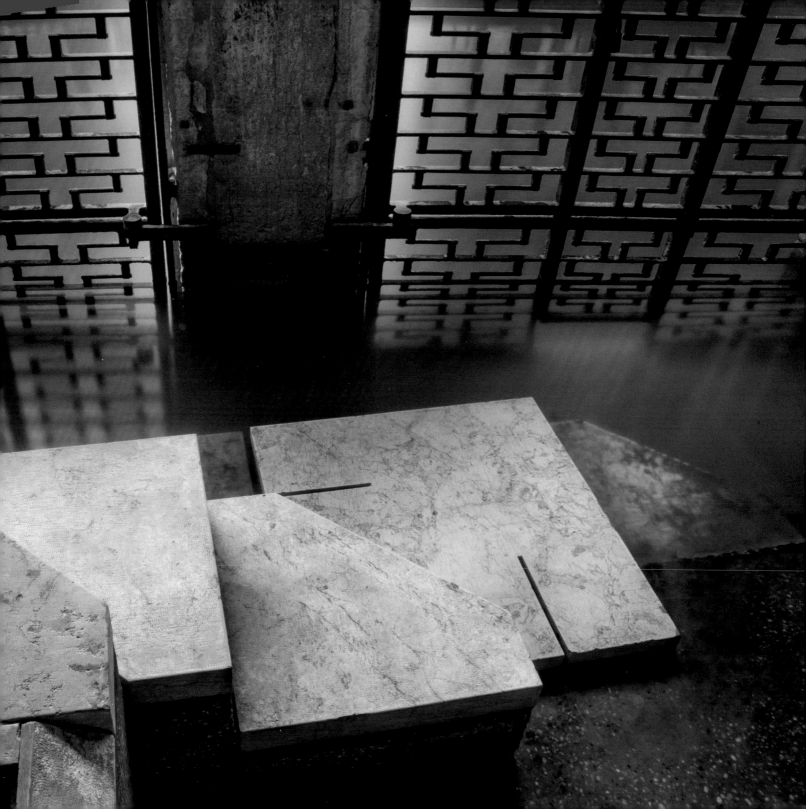

Anne-Catrin Schultz

When approaching Venice, the city always comes into view as a surprise, a little tremor in my perception—floating in the distance, an urban and architectural apparition. Venice and its morphology have changed little since the 15th century, a permanence that is mostly owed to the absence of the automobile. The city is explored by being cradled on the water of the canals or by foot through its *calli*. Buildings are multiplied by their own reflection—an unquiet symmetry lives along a changing tidal line reflecting asymmetrical facades. Man-made surfaces, worn down by steps and gazes, are licked by the water and humidity of the lagoon. Layers of wood, stone, brick, stucco, glass and gold are embedded into a breathing liquid system that rises and falls like clockwork. Venetian buildings are a layered affair—structures clad in stucco and marble in continuous decay and re-construction. Highly artificial, Venice is as close as man-made objects can come to nature. Peeling surfaces of pristine patterns form a laboratory of Byzantine, Roman, Islamic architectures. They are living and breathing architecture history, read by the informed and admired by many.

I studied Venice through the Giardini and the spaces of Carlo Scarpa embedded in the Biennale exhibits and its structures—his layered integration of art and space, of historic fabric and contemporary commentary. His ticket pavilion at the Biennale holds a framed sail as a roof, almond shaped spaces, transparent and solid layers of walls, and ship masts acting as columns—a tiny concentrated story of Venice and beyond. Scarpa's work has inspired me to *read* architectural conversations set in a continuous flow of time. It has triggered an ongoing exploration of materialized cultural narratives set in their tidal context of history and place as I search for depth and beauty in architecture.

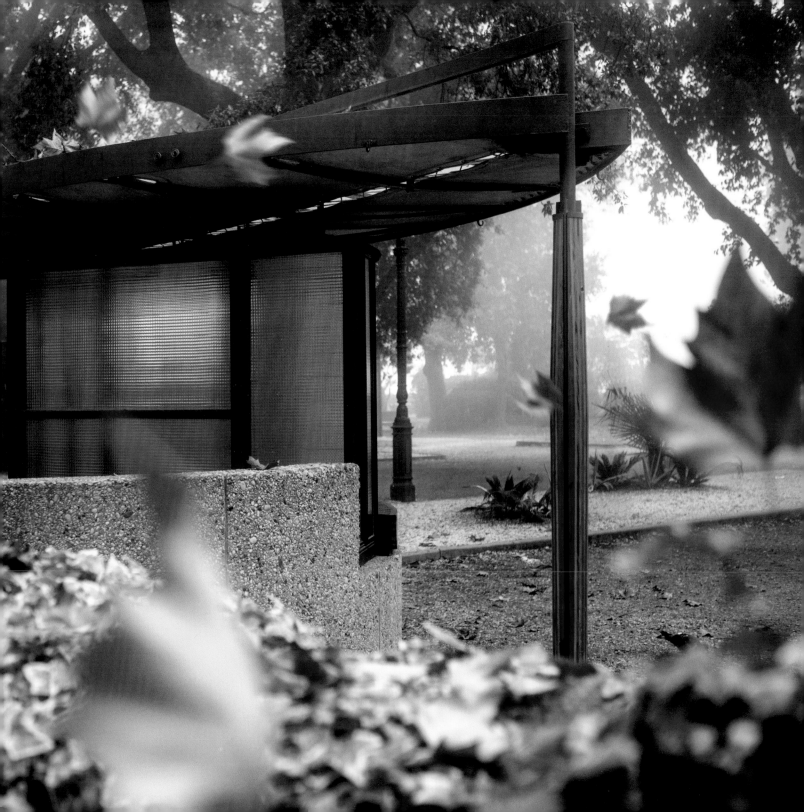

TAMassociati

Venice is a city of commons: it exists out of the lagoon waters only for this reason. It was born and expanded because of collective efforts and shared rules. In recent years the weakening of the city's sense of commons risks destroying its uniqueness, allowing shopkeepers and cruise operators to exploit its heritage exclusively for private purposes, jeopardizing Venice's future as a city.

Venetians have always blended public and private interests in a unique way, in order to create their own identity, but now Venice has gone far beyond our contemporary sense of commons. Traditionally, the practice of all professions—be it politics, trade, art, architecture, or crafts—was ultimately meant to increase the glory of La Serenissima, and was regulated by a precise and complex set of norms, in order to protect the idea of the City as a common good. The delicate balance between natural environment and human need was created day by day, in a continuous work of mutual understanding, sharing, and control. A set of dedicated administrations served this purpose, and punishments for corruption were extremely hard. It was a matter of survival: water management is a challenging task, and Venice based its power precisely on its confidence with water. Venetian citizens were aware of that, and acted to protect and increase their position in the community, as if they were members of a crew.

As a team of architects, living and working in Venice, we recognize these values in every aspect of city life, from the urban, to ecological and social, and we always wish to see them reflected in city politics as well. As architects we study, discover and solve specific problems—in building technique; in environmental engineering; in hydraulic knowledge; in craftsman expertise; in arts, math and sciences—but as citizens we must learn from our city's history of shared values.

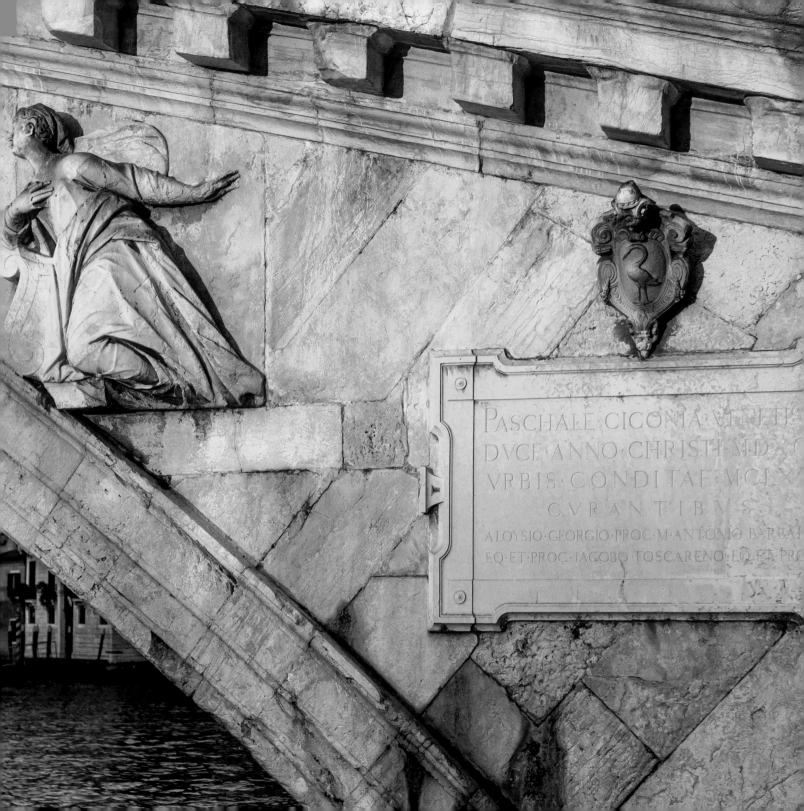

PASCHALE CICONIA VENETI
DVCE ANNO CHRISTI MD
VRBIS CONDITAE MCL
CVRANTIBVS
ALOYSIO GEORGIO PROC M ANTONIO BARBA
EQ ET PROC IACOBO FOSCARENO EQ ET PRO

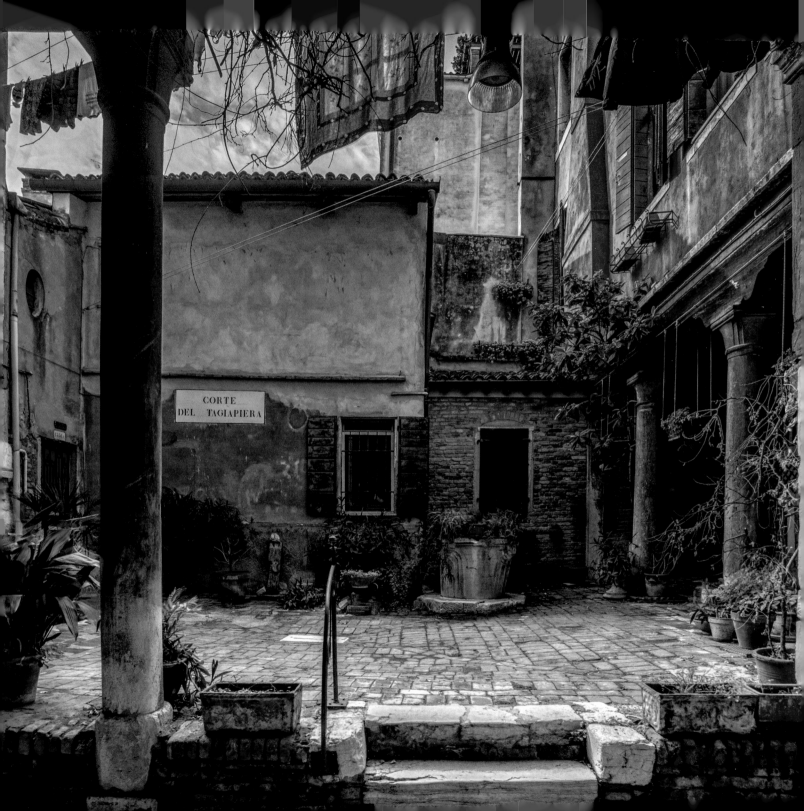

Contributors

Tadao Ando is a self-taught architect from Japan. In Venice, he has designed the restorations for Palazzo Grassi and Punta della Dogana. He is renown for his elegant use of concrete and spatial volumes. He has won numerous international awards, including the Pritzker Architecture Prize in 1995. tadao-ando.com

Enrico Baleri is an award-winning Italian design entrepreneur and producer of cultural events in architecture, art, and industrial design. He has four products in the permanent collection of MoMA: Spaghetti Chair and Spaghetti Stool with Giandomenico Belotti, Chair Second with Mario Botta, and screen Cartoons with Luigi Baroli. ebricerche.it

James Biber leads his architectural firm in New York's Woolworth Building, designing a wide range of projects from private residences and museums to restaurants, schools and everything in between. The firm's USA Pavilion at Expo Milano 2015 has attracted Expo's largest crowds and universal praise from the design press. biber.co

Randy Bosch's work emphasizes healthcare architecture and community planning. Honored for design and leadership, his greatest honor is to serve. Randy publishes *RenaissanceRules.com*; writes leadership, architecture and cultural critiques; consults with select clientele; and loves Venice. His work explores intentional urban design, pre-historic architecture, Venice (including *sotoporteghi*) and ethics.

Mario Botta was born in Mendrisio (1943) where he still lives and works. From the first single-family houses in Ticino, his practice has encompassed all building typologies: schools, banks, administrative buildings, libraries, museums and sacred buildings. In 1996 he was a prime mover of the Academy of Architecture in Mendrisio. botta.ch

Constantin Boym was born in Russia and graduated from the Moscow Architectural Institute. He received a Master's in Design from the Domus Academy in Milan and founded his award-winning studio in New York in 1986. Boym is the Chair of the Industrial Design Department at Pratt Institute. boym.com

Louise Braverman is an award-winning architect who established her New York-based firm in 1991. A graduate of the Yale School of Architecture and a Fellow of the American Institute of Architects, she presented her work at the Venice Architectural Biennales in 2012 and 2014, and was invited to exhibit again in 2016. louisebravermanarch.com

Vincenzo Casali is a visual artist and architect in Venice, Italy. His studio specializes in urban design projects and exhibition installations. His architecture is characterized by its clean line and precise imagery. As an artist, he investigates the relationship between space and the work of art. vincenzocasali.it

Francesco da Mosto is a Venetian architect, author, filmmaker and television presenter. He has presented four BBC 2 television series on Italy, Venice, the Mediterranean and Shakespeare, and has written four best-selling books. His family arrived in Venice in the ninth century. francescodamosto.org

Cynthia Davidson, co-curator of the United States Pavilion for the 2016 Venice Architecture Biennale, is a writer and the editor of the international architecture journal *Log* and the Writing Architecture Series of books, based in New York. anycorp.com

Michele De Lucchi received his architecture degree in Florence, Italy. During the period of radical and experimental architecture, he was a prominent figure in movements like Cavart, Alchymia and Memphis. His professional work has always existed alongside a personal exploration of architecture, design, technology and crafts. amdl.it

Massimiliano Fuksas was born in Rome and received his architecture degree from the University of Rome. For many years, he has been devoting special attention to urban problems in large metropolitan areas. Studio Fuksas has completed more than 600 projects in Europe, Africa, Asia, and Australia, receiving numerous international awards. fuksas.com

Jonathan Glancey is a critic, journalist, author, and broadcaster. He currently writes for the *Daily Telegraph*, *L'Architecture d'Aujourd'hui*, *Architectural Review*, and *BBC World*. His books include *New British Architecture, C20th Architecture, Lost Buildings, London: Bread and Circuses, Dymaxion Car: Buckminster Fuller* (with Norman Foster), and *The Story of Architecture*. biennalebooks.com

Richard J. Goy is a practicing architect and author. He has expertise in the conservation and restoration of historic buildings, and is published extensively in the field of architectural history, especially that of Venice, for which he is an international authority. He divides his time between London and Venice. richardjgoy.com

Frank Harmon is an architect, educator, and author of *NativePlaces.org*. He has designed sustainable modern buildings across the Southeast for 30 years. Founded in 1981, Frank Harmon Architect is a design studio whose work engages pressing contemporary needs such as sustainability, placelessness, and the restoration of cities and nature. frankharmon.com

Guy Horton is a Los Angeles-based writer and contributing editor for *Metropolis* magazine.

Michael P. Johnson is an autodidact, establishing his practice after apprenticing for 10 years. His organic approach to architecture is reflected in a constant exploration of surfaces and volumes. He taught for 26 years at the Frank Lloyd Wright School of Architecture at Taliesin West in Scottsdale and Taliesin in Wisconsin. mpjstudio.com

Shun Kanda is an architect-educator, currently Senior Fellow at the MIT Department of Architecture. He is Director of VE_italia, an open program on critical design thinking inspired by Carlo Scarpa's oeuvre and pedagogy. Kanda also directs the iADW_international Advanced Design Workshops in Japan, US, Italy and Bhutan. M.Arch Harvard. eTOPOS.org, venetoexperience.com

Max Levy lives and works in Texas where he seeks to bring sun, wind, rain, and sky into play architecturally. His heroes include Carlo Scarpa and Louis Kahn, and he is inspired by Venice for the way in which it is so thoroughly interwoven with nature. maxlevyarchitect.com

Jürgen Mayer H. studied architecture at Stuttgart University, at Cooper Union New York and at Princeton University. His work has been published and exhibited worldwide, and is included in private collections as well as numerous museums such as MoMA and SFMoMA. He has won numerous international architectural awards. jmayerh.de

Robert McCarter is a practicing architect, author, and Ruth and Norman Moore Professor of Architecture at Washington University in St. Louis. He is the author of *Steven Holl, Aldo van Eyck, Herman Hertzberger, Alvar Aalto, Carlo Scarpa, Louis I. Kahn, Frank Lloyd Wright, Wiel Arets, Frank Lloyd Wright: Critical Lives*, and *Understanding Architecture* (with Juhani Pallasmaa), among others.

William Menking is an architectural historian, writer, critic, and curator of architecture and urbanism. He is professor of architecture, urbanism, and city planning at Pratt Institute, and has lectured and taught in the United States and Europe. He is the founder and editor-in-chief of *The Architect's Newspaper*. archpaper.com

Richard Murphy is the founder of Richard Murphy Architects, an architectural practice in Edinburgh, Scotland. He is the author of books on Carlo Scarpa and Rennie Mackintosh, and has exhibited at the Venice Architecture Biennale. In 2007 he was appointed an OBE (Order of the British Empire). richardmurphyarchitects.com

Louise Noelle is the former editor of *Arquitectura/México*, a professor at the National University of Mexico, author of publications on architecture and urbanism, and a contributor to numerous architectural journals. She is a member of the Mexican Arts Academy, ICOMOS and DOCOMOMO; Honorary Academician of the Society of Mexican Architects and of the Argentinean Academy of Beaux Arts.

Dial Parrott is a graduate of Princeton University and the University of Virginia who has worked as a journalist, teacher, and lawyer. He is the author of *The Genius of Venice: Piazza San Marco and the Making of the Republic* from Rizzoli Ex Libris.

Valeriano Pastor is an Architectural Design Professor and a former Director of the Architecture University of Venice, IUAV. He is also responsible for a complex extension and renovation plan at Fondazione Querini Stampalia focusing attention on how to improve the spatial distribution. During the 1950's he collaborated with Carlo Scarpa. studiopastor.it

Guido Pietropoli studied architecture at the University Institute of Venice. He worked with Atelier Le Corbusier on the Venice Hospital, and, until 1978, with the legendary Carlo Scarpa. An architect for 40 years, he lives in the Veneto where he studies and writes about the Venetian *maestro* Scarpa. studiopietropoli.it

Carlo Ratti is an Italian architect, engineer, inventor, educator, and activist. Carlo Ratti Associati is based Torino, Italy, with branches in Boston and London. His studio merges architecture and urban planning with cutting-edge digital technologies. He's also the founder and director of the MIT Senseable City Lab in Boston. carloratti.com

Witold Rybczynski is an architect, professor, critic, and writer. He studied architecture at McGill University in Montreal, where he also taught for twenty years. He is Emeritus Professor of Urbanism at the University of Pennsylvania. Rybczynski has written 19 books and over 300 articles and essays. witoldrybczynski.com

Anne-Catrin Schultz studied architecture in Stuttgart, Germany, and Florence, Italy. Following post-doctoral research at MIT exploring the mechanics of *layering* in architecture, she now practices, teaches and writes in Boston. Her books concentrate on buildings in historic context, Carlo Scarpa and the evolution of architectural tectonics.

Annabelle Selldorf is the Principal of Selldorf Architects, a 65-person architectural practice that she founded in New York City in 1988. The firm has worked on public and private projects that range from museums, libraries and galleries to a recycling facility. In Venice, the office designed *Le Stanze del Vetro*. selldorf.com

TAMassociati is a team of architects based in Venice, winner of several prestigious awards (Aga Khan Award, Curry Stone Design Prize, Italian Architect of the Year and others) for qualitative excellence and for the eco-social impact of its works. TAMassociati is Curator of the Italian Pavilion at the Venice Biennale 2016. tamassociati.org

J. Michael Welton writes about architecture, art and design for national and international publications, and edits a digital design magazine at *architectsandartisans.com*. He's also architecture critic for *The News & Observer* in Raleigh, North Carolina; and author of *Drawing from Practice: Architects and the Meaning of Freehand* (Routledge Press, 2015).

Thomas Woltz is principal and owner of Nelson Byrd Woltz Landscape Architects with offices in New York City and Charlottesville, VA. In 2011, he was invested into the American Society of Landscape Architects Council of Fellows, and was named Design Innovator of the Year by the *Wall Street Journal* in 2013. nbwla.com

Diana Yakeley is the interior design partner in Yakeley Associates, an architectural practice in London. Twice past President of the British Institute of Interior Design, she has also written several books on design and gardens. In 2016 she was appointed an OBE (Officer of the Order of the British Empire) for services to the UK Interior design profession. yakeley.com

Rocco Yim is a co-founder of Rocco Design Architects, a Chinese architectural practice based in Hong Kong. He is involved in dialogues with the cultural and architectural communities, both locally and overseas. The firm has received numerous international awards and has exhibited four times in the Venice Architecture Biennale. rocco.hk

Riccardo De Cal

Riccardo De Cal was born and lives in Asolo, Italy. After receiving his degree in Architecture at IUAV in Venice he has developed a career as an award winning documentary filmmaker and photographer. His research is focused on the themes of suspension of time and abstraction of spaces.

In 2002 De Cal directed his first short film, presented at the Pitti Palace in Florence. In 2005, he directed *La Città del Silenzio*, a short documentary film that won several prizes and was screened at the Cannes Film Festival. In the same year he collaborated with the Benetton Foundation, directing two documentary films—*Memoriae Causa* on Venetian architect Carlo Scarpa and *Quando l'arte si tace* about the painter Gino Rossi. The films have been screened at various international film festivals and have won numerous awards. *Memoriae Causa* was also presented in London at Sir John Soane's Museum in collaboration with the Royal Institute of British Architects, and at the Milan Triennale of Architecture.

In 2007 De Cal received the RdC Award, along with Carlo Lizzani, Silvio Soldini and Vincenzo Vincenzoni at the Third Millennium Festival in Rome. In 2010 he presented his film *Raccolto d'inverno*, about Italian sculptor Alessio Tasca, during the 67th Venice International Film Festival. In 2012 and 2013 he directed two more films about Carlo Scarpa that were screened at MAXXI, the National Museum of XXI Century Arts in Rome and at Palazzo Grassi-Pinault Foundation in Venice. In 2014 De Cal curated a double video installation for Grand Hornu Images Museum in Belgium and screened two films at the Lisbon Architecture Film Festival. A short film about the Fluxus art movement was included in the exhibition at the Venice Pavilion in the Venice Art Biennale 2015. riccardodecal.com

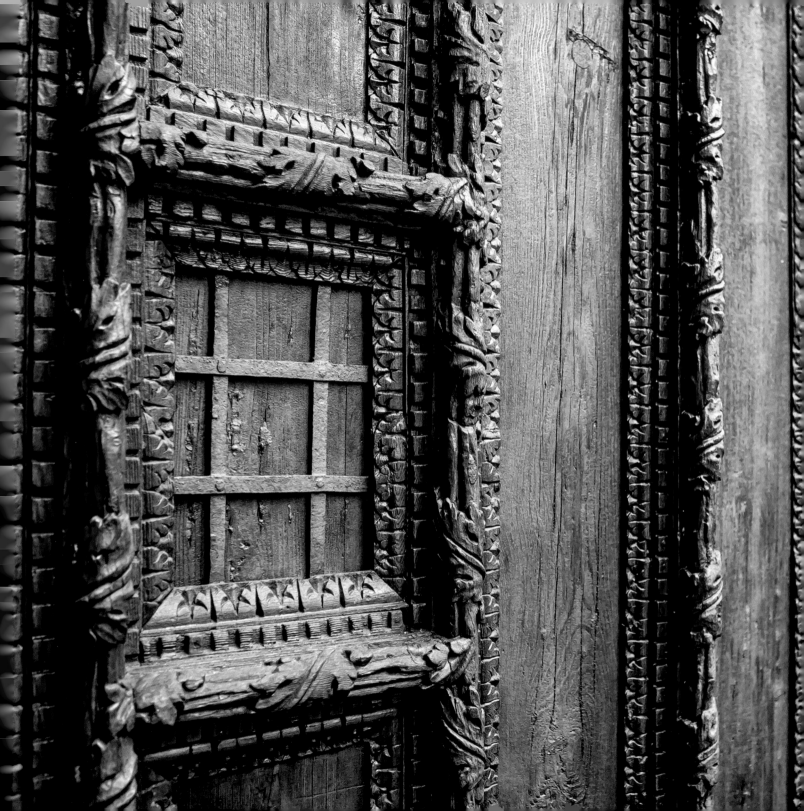

Acknowledgements

To the contributors who generously shared their experiences of Venice, you have helped us to see this enigmatic city in the context of urban design. Each of you has written a reflection that deepens our understanding.

To Eugenio Tranquilli, you may be the kindest person I have never met.

To Lorenzo Bianchi, you taught me the necessity of working with a translator who knows his Hegel from his Schopenhauer. You saved me more than once.

To Sandy Popovich, we are able to present Venice as a contemporary city because of your fierce passion and talent for graphic design.

To Riccardo De Cal, your artistic eye has captured a noble and habitable Venice, one that must be lived in to survive.

To all of you, grazie di cuore.

JoAnn Locktov
Publisher

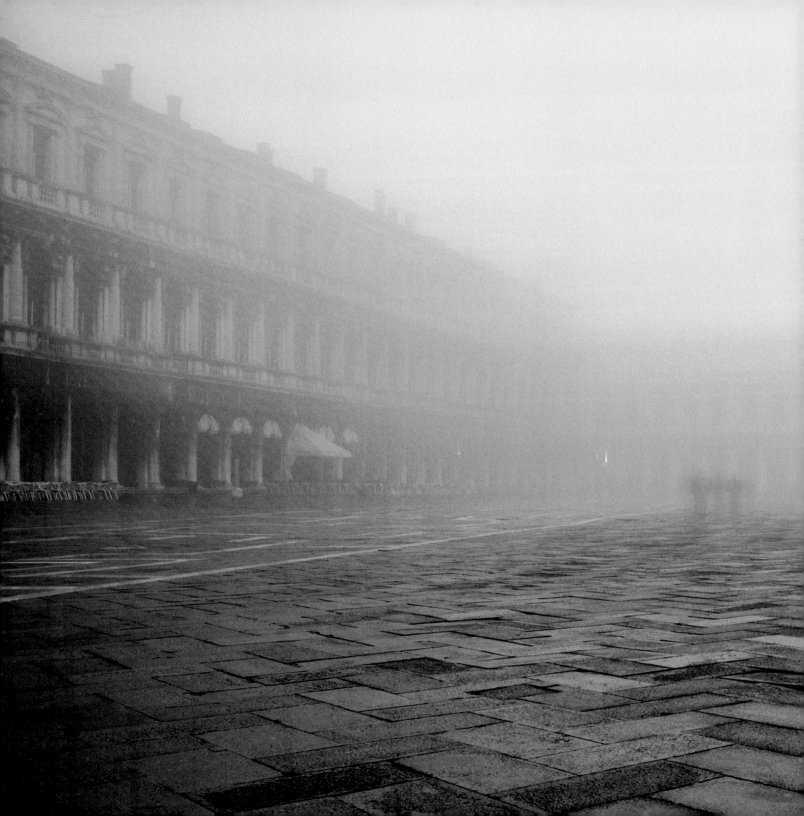

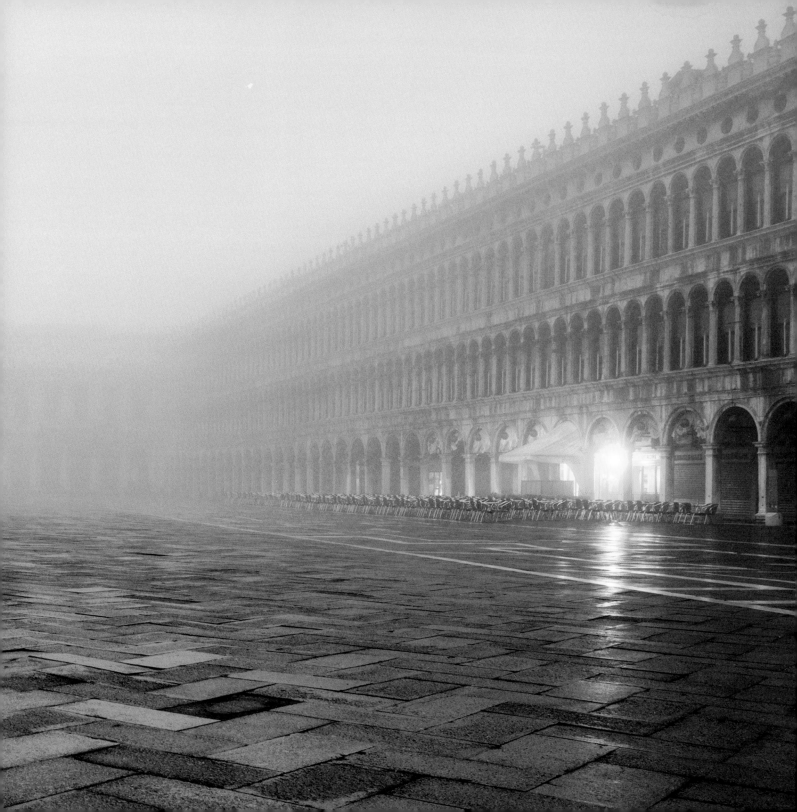

Designer: Sandra Popovich

Printed in Canada
ISBN 978-0-9907725-1-4
First Edition

Bella Figura Publications
bellafigurapublications.com
+1.415.847.6374